ORBIS CONNOISSEUR'S LIBRARY

ROCOCO
a style of fantasy

TERENCE DAVIS

ORBIS PUBLISHING LONDON

Contents

Designed and produced by Harriet Bridgeman Limited

© Istituto Geografico De Agostini, Novara 1973
English edition © Orbis Publishing Limited, London 1973
Printed in Italy by IGDA, Novara
SBN 0 85613 130 X

Rococo is the frivolous, wayward child of noble, grand Baroque. The parent was born in Italy, the child in France. The Baroque (*barocco*, a rough pearl) developed in the early seventeenth century and spread rapidly throughout Europe. At first predominantly a sculptural and architectural style, its greatest exponent and genius was Gianlorenzo Bernini (1598–1680) who, like Michelangelo before him, was first and foremost a sculptor, but turned naturally to painting, theatrical decorations and architecture while serving several Popes in the remodelling of Rome. His 'Ecstasy of St. Teresa' and the small church of S. Andrea al Quirinale in Rome both reveal the tendencies which lead on to the rococo style: a brilliant use of light and shade on expensive and elaborate materials, such as coloured marbles and bronze.

The seventeenth century was an age of grandeur, of strong religious sentiments expressed clearly and forcibly in striking visual forms in the paintings of Caravaggio and Cortona, the sculptures of Bernini and the architecture of Borromini. Its most important manifestations were Italian, and it was really the swansong of Italy as a creative power, for already at the death of Pope Urban VIII, Bernini's patron, the new star was making its appearance: France, which was to continue her meteoric rise throughout the century and dominate fashionable and artistic Europe in the succeeding century.

The rococo style in France

In 1651 the young Louis XIV came of age and by the 1660s any dissensions in France had been totally suppressed, so that Louis could devote his attentions to the building and decoration of his palace at Versailles. Here, the Italian baroque style was adopted and modified by Louis' all-powerful artist, designer and interior decorator, Charles Lebrun, to glorify not the saints of the Catholic Church, but the King of France *Le Roi Soleil*. Louis' absolute rule involved not only visual proof of his supremacy, but an elaborate court etiquette as stiff and unnatural as the gardens laid out by Le Nôtre around the Palace. This extreme formality was felt in such apartments as the famous Hall of Mirrors and the multicoloured Ambassa-dors' Staircase, and it is against this background that the Rococo is set; France was demonstrating that already she was arbiter of taste and eager for novelty.

The Rococo is rightly associated with the eighteenth century in France, but even within the last years of the previous century indications of the new style appear, as in the work of the court architect, Jules-Hardouin Mansart (1646–1708), at the Trianon at Versailles, and at Marly, another royal residence. In these two buildings Mansart broke away from the stultifying use of marble and bronze, turning rather to wooden panelling and paler colours. The very scale of the Trianon indicates a desire to escape from the grandiose palace, a feeling which occasioned a number of highly significant works in the eighteenth century.

Louis XIV appears to have much encouraged this reaction, as illustrated by his famous injunction to Mansart concerning the decoration of the room of the very young Duchesse de Bourgogne in the Château de la Ménagerie: 'You must spread everywhere the feeling of youthfulness' (*Il faut répandre partout la jeunesse*). This was in 1699, and the King still had another sixteen years to live, years which were to determine the course of art and decoration for at least the next generation, not only in France but as far afield as Sicily and Austria.

If the Rococo was specifically a French creation, many factors from further afield influenced and fostered the style, as, for example, the graphic works of such seventeenth-century Italian artists as Stefano della Bella, who spent a long time in Paris. In his designs delicate, feathery lines enfold forms which are often purely decorative in intent, as much rococo art was to be.

Many engraved books from the last decades of the seventeenth century reveal the rococo style in embryonic form. The tight scroll-work so characteristic of Flemish and German renaissance decoration, and even of the School of Fontainebleau, was liberated, making it less severe and symmetrical, and fantastic elements were introduced, unknown in the originals. This is seen in France in the furniture of André-Charles Boulle and in Venice in the furniture of Andrea Brustolon, where curving, intricate baroque forms began to be modified around the turn of the century.

One of the first appearances of the new style in a highly important setting is in the bedroom of Louis XIV at

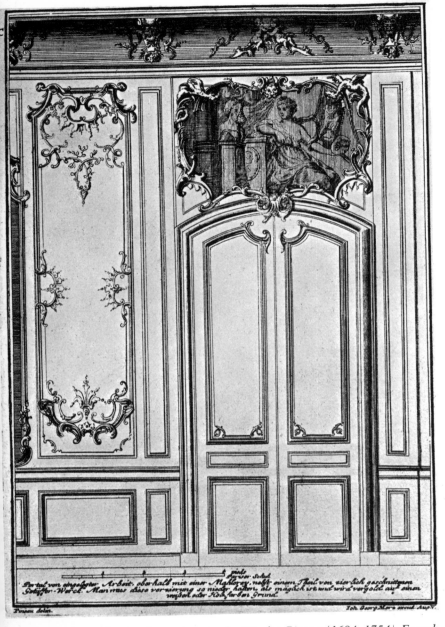

Design for an interior by Nicolas Pineau (1684–1754), French Engraving. (Victoria and Albert Museum, London)

Versailles. This was redecorated c.1701 mainly in white and gold, relying entirely for its effect on the crisp contrasts of finely sculptured pilasters against rich areas of gilded carving, and, set above the chimneypieces, large mirrors with rounded tops. Large areas of Venetian mirror-glass were, of course, important decorative features as early as the creation of the Galerie des Glaces, and also of the Mirror Room in the Grand Trianon: they have often been mistakenly identified solely with the advent of the rococo style, in which, indeed, they were to play an important part. The design of Louis' bedroom, however, still bears witness to a strong preference for the Classical Orders, with pilaster decoration in the typically academic seventeenth-century tradition.

One of the problems of any examination of rococo decoration is that we are uncertain as to how much of it originated from the small army of draughtsmen, whom leading figures such as Mansart kept behind the scenes, and how much from the great architects themselves. Thus, while a building or an interior passes as the work of Mansart or De Cotte, the novel details in it may just as well have sprung from a 'ghost' designer with a certain sense of fantasy and an originality which the Royal Architect passed off as his own.

These draughtsmen were in all probability familiar with books of decorative patterns derived from the Italian Renaissance and illustrating the famous grotesques of Raphael in the Villa Madama and the Vatican Loggie. Grotesques, descended from the stucco reliefs and paintings in Roman tombs (or grottoes, hence 'grotesques'), played an important part in French decoration as early as the 1650s and later appeared in some of Lebrun's own decorations, such as those in the Galerie d'Apollon in the Louvre. They consisted of curving plant-and-scroll forms, often originating in an urn or pot and winding upwards in a regular pattern, inhabited by playful monkeys, insects and other creatures who provide a slight asymmetrical touch. The lightness of this type of decoration was borne in mind by Pierre Lepautre when he decorated the King's suite of rooms at Marly in 1699.

Lepautre's interiors at Marly are, tragically, known to us only from drawings. They show that he dispensed with the heavy, rectangular frames around doors and mirrors, replacing them with miniature curving decorations integrated into the corners of mouldings, which themselves were finer and more elegant in effect than ever before. In place of the traditional painted and gilded ceiling, Lepautre simply articulated the great white plaster expanse with a delicate gilded rosette at the centre – this was to be imitated on both ceilings and panelling throughout the rococo period.

The rococo style developed most strongly during the Regency of the Duc d'Orléans (1715–23), whose town residence was the Palais Royale. Here, licence was the rule, and the tone of rococo society was set: a society which demanded constant novelty, wit and elegance – precisely the qualities of the rococo style. Society opened its doors to people whom Louis XIV would never have accepted: the newly rich and increasingly important intellectuals. During the Regency much of the aristocracy, which had found itself confined to Versailles during Louis XIV's reign, returned to Paris and commissioned new town houses, as in the Place Vendôme, where the transitional style can still be clearly seen.

Their interiors did not call for the elaborate ceiling-paintings of the previous century, and in their place a new school of painters emerged who specialized in the gently curving *trumeaux* (over-doors) and small-scale painted panels which form a great part of, for example, Boucher's output. Also in constant employment from this period until the Revolution were the *sculpteurs*, who executed the often minutely detailed carving on the *boiseries*, the decorated panel-framings.

It was in about 1720 that the transitional style began to give way to a clear rococo style. The term 'rococo' probably derives from the French *'rocaille'*, which originally referred to a type of sculptured decora-

tion in garden design. Certainly the leading designers of the rococo style, Gilles-Marie Oppenordt, Nicolas Pineau and Juste-Aurèle Meissonnier, were very much aware of it. The grotesques of the seventeenth century were now transformed into arabesques under Claude III Audran, Watteau's teacher, full of a new fantasy and delicacy.

The main steps forward were made in interior decoration and painting, while little of importance happened to the appearance of the exterior, except that a certain light sophistication replaced the heaviness of the Louis XIV style, and, instead of relying on the Classical Orders, architects such as Jean Courtonne and Germain Boffrand produced buildings whose main effect lay in the subtle treatment of stonework and the skilful disposition of delicate sculpture against sophisticated rustication. In Paris, two of the best examples are the famous Hôtel de Matignon of 1722–23 and the Hôtel de Torcy of 1714.

In interior decoration a steady progression towards extreme elaboration is seen during the Regency, as demonstrated by the Palais Royale and Hôtel d'Assy, culminating in such triumphantly sophisticated rooms as the Salon Ovale of the Hôtel de Soubise in Paris (1738–39) by Boffrand, whose influence on German rococo architecture was to be considerable.

A tendency to replace the huge series of very formal apartments favoured in the Louis XIV period with smaller, more intimate rooms is also seen, as in the Petites Appartements in Versailles, where form follows function more closely. Sadly these, together with many of the greatest rococo rooms, have disappeared without trace. Apart from Paris, much fine architecture and decoration in the full-blown rococo style was effected at Nancy, where the dethroned King of Poland lived.

Paradoxically, the rococo style was heralded in painting, much earlier than in the other arts, by a Flemish painter, Antoine Watteau. He moved to Paris in about 1702 and began working as a theatrical scene-painter, before studying with the Keeper of the Luxembourg Palace, Claude Audran, an artist who painted in a decorative, late baroque style. It was the Rubens 'Life of Marie de Médicis' series in the Luxembourg Palace which most impressed Watteau and through him was to influence the course of French rococo painting. He studied these together with the great Venetian painters and, in the words of Michael Levey, although he had '. . . no public career, no great commissions from Church or Crown; seldom executed large-scale pictures: had no interest in painting historical subjects . . .', unlike most of his contemporaries, he became the greatest French (by adoption) artist of the first half of the century.

Watteau's pictures, with their combination of Rubensian colour and his own delicate eroticism, were always more than a little melancholy. The lyrical quality of his painting, with its suggestion of sophisticated amorality, was precisely that sought by French society in the Regency years: Watteau was not only catering for a taste but also creating one.

The other two major painters of the French rococo period, François Boucher (1703–70) and J. H. Fragonard (1732–1806), both purveyed an entirely different variety of the style from that of Watteau and are often thought to have vulgarized where Watteau had refined. Whereas

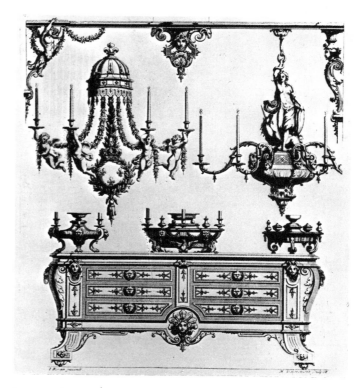

Design for a sideboard and candelabra by Jean Bérain (1637–1711), French. Engraving. (Victoria and Albert Museum, London)

Watteau achieved an all-enveloping aura of aristocratic distancing, Boucher and Fragonard produced a more intimate and obvious effect.

Significantly, Boucher's career opened as an engraver of Watteau's pictures, and from then on assumed the pattern of traditional success. Winning the Prix de Rome, he worked in Italy from 1727 to 1731. In 1734 he became an Academician, and with the help of his friend and Louis XV's mistress, Madame de Pompadour, he became the most sought-after painter in France for every type of picture, but in particular for his vivid renderings of mythological and classical subjects. In these, often rendered in a somewhat unsubtly erotic vein, Boucher, like Watteau, revealed a strong debt to Rubens and Venetian art, especially to Veronese, his finest predecessor in painting brilliantly clothed and displayed mythologies.

Boucher became Director of the Academy in 1765, and altogether made a highly important contribution to the rococo movement through his many paintings and his designs for tapestries and other decorations.

In the unreality of most of his later forms one recalls Sir Joshua Reynolds' sense of outrage at discovering Boucher had forsaken models. By comparison with the unreal world of Watteau, Boucher's settings are still less real, while the contrast with Gainsborough, who composed his landscapes with pieces of mirror, twigs and moss, is still more extreme. Miniature trees surround rustic buildings, which appear to have been made in icing-sugar, and water looks as if it were made of glass. There is no real light and shade, perhaps so as not to contrast too strongly with the surrounding pale and shallow rococo *boiserie* decoration into which it was set.

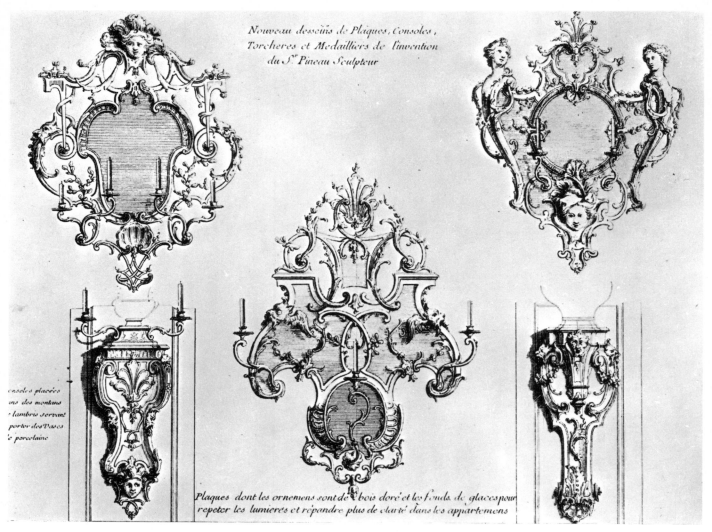

While there were a number of great individual artists, there were also families of painters who followed an almost unchanging stylistic tradition. Among these are the Coypels, who executed the chapel ceiling at Versailles, the Van Loos and the De Troys, all of whom painted consistently amusing pictures for the upper classes and for the rising middle classes, who appear for the first time in the rococo period as important patrons and to some extent account for the increased demand for portraiture. Some of the most delicious evocations of the sophistication of society are found in the portraits of Nattier, Drouais, Roslin and, of course, Boucher himself, whose delicate likenesses of Madame de Pompadour are among the finest portraits of any woman in that century.

Alongside portraiture, many other specialized branches of painting arose, such as the still life, where Jean Baptiste Oudry (1686–1755) and François Desportes (1661–1743) were foremost.

In the field of the still life one man is outstanding: Chardin (1699–1779). His delightfully simple and deeply sincere genre subjects and his still life paintings have a quality which seem at first glance closer in feeling to Dutch seventeenth-century realism – with an added dash of French precision and sensibility – than to the prevailing rococo style. A masterpiece could be born from a tiny

Designs for plaques, consoles, torchères and medailleurs by Nicolas Pineau (1684–1754), French. Engraving. (Victoria and Albert Museum, London)

picture of a Delft vase with a few freesias or from a simple two-figure study. It is their very delicacy and refinement that links them to the rococo.

The same delicacy characterizes the furniture and other decorative arts of the period. Between c.1715 and c.1770 French craftsmen created furniture which remains unparalleled in its beauty of line and detail, minute finish and costly materials expertly used. Also in this period most of the furniture types with which we are familiar today came into being: such pieces as the writing-table (*bureau plat*), the secretaire (of many different types, notably the drop-front and cylinder type) and the sofa in many guises (*canapés, lits de repos.*)

The heavy pieces of the later seventeenth century inlaid with brass and tortoise-shell in the manner of Boulle were replaced from the Regency onwards by smaller, lighter pieces, a development that coincided with the decrease in the size of rooms and the lessening formality. The chest-of-drawers (*commode*) was lifted off the floor on delicate curving legs, and *bombé* fronts were covered with sinuous ormolu which often flowed over the entire piece

6

and in which much of the finest decoration of the Rococo is found. Superb uses were made of inlaid woods of all types, often imported from the Orient, contributing both to the high cost of the piece and to the craze for the exotic which invaded French society and led to the use (often entirely misplaced) of terms such as '*à la polonaise, à la grecque* and *à la chinoise*'. In furniture the major manifestation of this interest in the Orient was in the use of imported or imitation lacquer, many good pieces of Oriental lacquer suffering badly in the process of dissection and reshaping.

The display of luxury was not, of course, confined to furniture, and the stark appearance of many rococo ensembles today is misleading. The frivolities and trimmings – frills, ribbons, elaborate hangings on beds, doors and windows, festoons of fringes, gimps and baubles – often only associated with the Victorians, added to the atmosphere of luxury and comfort, a quality little known in seventeenth-century French interiors.

It is said by Yvonne Brunhammer that, 'In spite of the extreme rigour of the Guild system, possibly even thanks to it, French furniture achieved, in the eighteenth century, such a state of perfection that it was sought after throughout Europe. The Guild regulations encouraged specialization and incited the sons of master craftsmen to continue in their fathers' trade by the prospect of economic advantages. The result was exceptional professional skill, and the rise of veritable dynasties of joiners and cabinet-makers, handing down the secrets of their craft from father to son'.

Thus, the *menuisier* practised only the creation of the actual form of the furniture; the *ébéniste* created the elaborate layers of inlay and surface decoration and yet another craftsman was responsible for fitting the gilt-bronze decoration over the prepared framework; no guild was permitted to intrude on the territory of another. As with the other arts, great names arose in each field: Foliot, Lelarge, Sené, Cressent, and an increasing number of Germans: Oeben, Riesener, Weisweiler. They rose to positions of great influence and a signed piece by one of these craftsmen was as sought after as any painting by Boucher or Fragonard.

The Rococo was a style in which the feminine element predominated, demonstrated in furniture in the supple and often sensuous curves, fragile appearance, and even terminology: *duchesse* (duchess) and *sultane* (sultana). Flowers decorated much of the wall-panelling and furniture of the period, and many rococo *boiseries* contain elaborate *trompe l'œils* of garlands and sprays of flowers inhabited by tiny birds and animals, the direct descendants of the grotesque. The small scale of much of the furniture, particularly pieces designed for writing, almost precludes its use by a man, although, paradoxically, one of the finest creations of the period, Louis XV's own desk executed by Oeben and Riesener between 1760 and 1769 is large and surprisingly masculine.

'Porcelain was sometimes incorporated into French furniture design, usually in the form of painted plaques or discs set in bronze frames. Much of it is from the factory of Sèvres. Louis XV had himself provided funds to back a porcelain enterprize at Vincennes, near Paris, specifically to imitate Meissen porcelain, which moved in 1756 to Sèvres. Although not the first factory in France to produce porcelain (Rouen and Saint-Cloud were both operating in the last years of the seventeenth century), Vincennes-Sèvres was certainly the most successful in its production of hard-paste porcelain, counting important painters such as Boucher among its designers.

The value attached to Sèvres porcelain is attested to by the number of individual pieces or sets such as that made for the Empress Maria Theresa in 1758 sent by Louis XV as diplomatic gifts. Other famous sets include the services made for Catherine the Great and Madame du Barry. The colours perfected at Sèvres are not so different from those found in Boucher's paintings – greeny blues and a wonderful pink known as *rose Pompadour*. The types of objects manufactured ranged from wall-sconces to ink-wells and *pot-pourri* vases, of which some of the finest examples are in the Wallace Collection, London.

The rococo style in France represented her greatest artistic contribution before the rise of Impressionism in the nineteenth century and embraced all the arts to an extent found nowhere else in Europe apart from Germany. The amazing quality of French Rococo is due to the maintenance of the highest standards throughout. It has the added appeal of patronage by such figures as Madame de Pompadour, with whom the style is identified, and it stood at the end of a long tradition of the finest French craftsmanship.

Design for chinoiserie decoration by Jean-Baptiste Pillement (1728–1803), French. Engraving. (Victoria and Albert Museum, London)

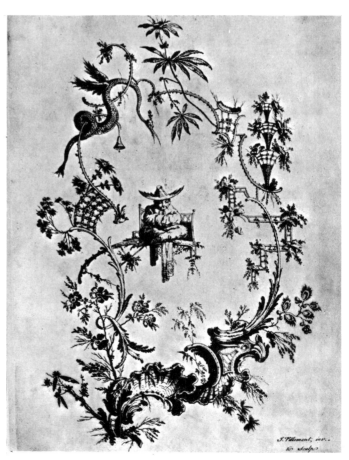

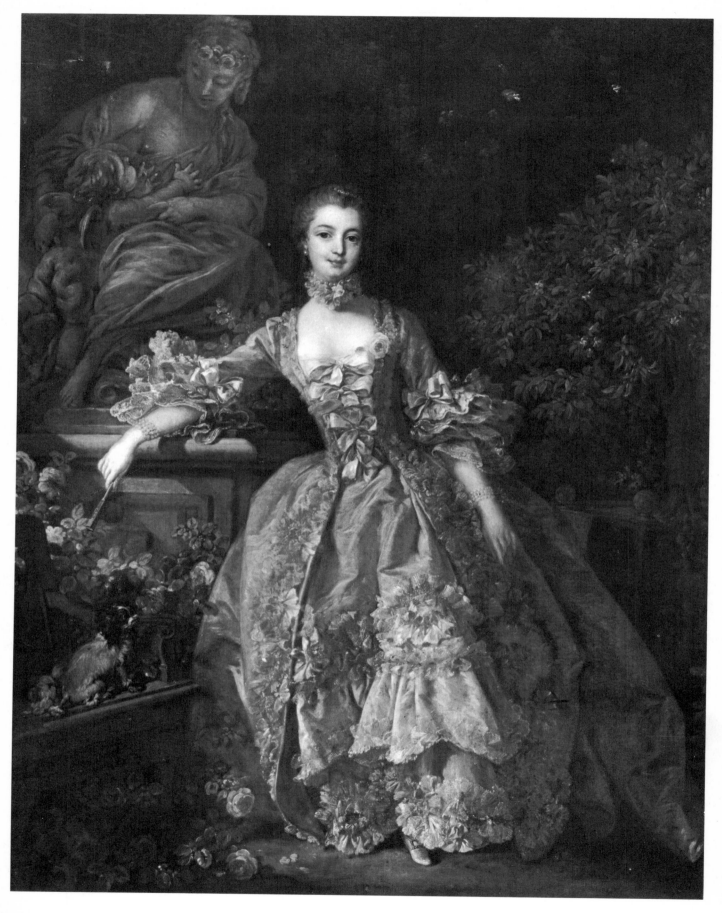

8

The rococo style in Italy

A large part of the story of the Rococo in Italy is that of painting in Venice – especially painting by the great genius Giambattista Tiepolo (1696–1770) – since the important products of the style in its most original form are found there. With the exception of some buildings by Juvarra and Bernardo Vittone, Italian architecture of the first half of the century passes fairly directly from the late baroque style to early Neoclassicism, with little evidence of a definite rococo style.

Architecture and decoration was dominated by the work of two men at the turn of the century, Bernini and Borromini, but in particular the latter. Soon, however, the leading architect in Rome was Ferdinando Fuga (1699–1782), a Florentine whose greatest works were the Palazzo della Consulta (1732–37) and the façade of Santa Maria Maggiore (1741–43). In the former, a delicate rhythm was created not by massive orders of columns but by subtly proportioned and slightly recessed panels. Against these were set highly decorative windows, and the whole was crowned by a large central sculpture of angels supporting a cartouche. It is much more sculptural in effect than any French building of the same date, and links up rather more with German Rococo.

The same central emphasis is found in the façade of Santa Maria Maggiore, but there the whole façade is conceived as an open loggia, relieved only by light sculpture.

Elsewhere in Rome, other architectural undertakings were coming closer to the spirit of the Rococo, as for example, in the Spanish Steps (1723–25) by Francesco de Sanctis.

While French architects such as Boffrand were searching for an economical means of expressing the sophistication of their interiors on the exterior, Italian architects were still very much more concerned with the exterior as the vehicle for an immediate impression. They often devoted their energies to this at the expense of the interiors and as a result only succeeded internally where huge spaces were involved, as in some of the works of Filippo Juvarra (1678–1736).

Juvarra was born in Messina into a family of silver-smiths and was trained in Rome under Carlo Fontana, gaining his first successes as a designer of elaborate and decorative stage scenery, an experience which was later to stand him in good stead. After being appointed First Architect to the King at the Court of Savoy in 1714, he travelled to Portugal, London and, in 1719–20, Paris, probably seeing French Rococo in its earliest stages.

On his return he became Italy's closest parallel to the French architect-designer, involved with not only architecture, but interiors, furniture and the applied arts. His outstanding achievements are the hunting lodge he designed between 1729 and 1733 for the Court at the Castle of Stupinigi, the Church of the Carmine (1732–35) in Turin, and the sanctuary of the Superga near Turin (1717–31).

Of these, Stupinigi is his most exciting creation. Gigantic wings radiate from a domed central core surmounted by a bronze stag, the white exterior preparing one for the incredible spatial acrobatics and colour inside the central Great Hall, which is close to many of Juvarra's architectural

Left: Portrait of Madame de Pompadour by François Boucher (1703–70). Oil on canvas. (Wallace Collection, London.) Above: Designs for a chimney-piece and panelling by Gilles-Marie Oppenordt (1672–1742), French. Etching. (Victoria and Albert Museum, London)

fantasies and theatrical drawings. Much use is made of illusionistic painting, *trompe l'œil* urns filling giant niches painted above the many chimney-pieces in the hall, while a gently swaying gallery runs round the walls and seems to pierce the great piers. It is a theatrical *tour de force*.

By comparison, the Superga and the Carmine seem a little pedantic, but the former is sensationally sited on a hilltop dominating the surrounding area with its elegant portico and high dome flanked by onion-domed towers.

Comparable to Juvarra was Bernardo Vittone (1704/5–1770), who worked exclusively in Piedmont, where he was born and to which he returned after studying in Rome and editing the great baroque architect Guarini's 'Architettura Civile'. His most important works are in obscure villages in Piedmont and unite Guarini's spatial complexity with Juvarra's lightness and *brio*. In this vein, his masterpieces are the Sanctuary at Vallinotto (1738–39)

and the church of Santa Chiara at Brà of 1742.

While Vittone's domestic architecture is pedestrian, Juvarra's is not, and his rococo interiors are among the finest in Italy. Unlike France, Italy was not ruled by one monarch, so patronage was usually limited to a particular area of the country, as in Juvarra's case. His patron, Vittorio Amadeo II of Savoy, was fortunate in having such an able court architect, and for him Juvarra designed the façade of the Palazzo Madama in Turin (1718–21), and some of the few interiors which approach the French in quality; such is the Chinese Room of the Royal Palace in Turin with its lacquer and gilded *boiseries*, influenced, possibly, by J.-A. Meissonnier's book of ornaments published in 1734. A comparison of Juvarra's interiors with others in Italy shows that he alone stood on an equal footing with other European designers.

Unfortunately the history of Italian rococo furniture does not follow such an easy pattern as the French. The style of the seventeenth century overlapped into the eighteenth, and pieces which are ostensibly datable before the turn of the century are often in fact much later. Much of Juvarra's furniture remains fairly heavy, using natural forms in quite a different way from French designers such as Nicolas Pineau or Meissonnier.

Splendour, left over from the baroque age, was still the dominant mood for all major interiors, and there was no feeling, as in France, or even Germany, for the small scale. Thus were produced more sophisticated but equally imposing furniture and settings. Whereas the French taste was for constant novelty, Italian interiors changed little after the initial swing to the Rococo had been accepted. As in France, and to a greater extent in England, the newly rich or moderately well-off were now trying to keep abreast of contemporary developments.

What surprised most foreign travellers to Italy was the emptiness of the great suites which lay behind the façades of most large palaces. Apart from the few splendid apartments on view, the palaces contained many undistinguished rooms and their contents could not compare with French furniture and the *chic* of Parisian styles, for which the Italians substituted tasteless extravagance. The pictures by Pietro Longhi of Venetian interiors conjure up the sparsely furnished rooms of many Italian rococo houses.

The figures of Andrea Brustolon and Antonio Corradini dominated Venetian design at the beginning of the century, their heavy baroque forms continuing to be produced by succeeding craftsmen well after their deaths, almost until the end of the century. The Venetians were nonetheless the only Italians who took the rococo style seriously to heart and emulated the French, producing exaggerated *bombé* commodes often teetering on tiny, fragile legs.

Few great names are known in the domain of Italian eighteenth-century furniture and one thinks mainly of highly important individual pieces such as G. M. Bonzanigo's painted and gilt firescreen in the Royal Palace at Turin. In Italy, even more than in France, an apparently insatiable demand for curious or unusual pieces arose, elaborately painted in the Venetian style with rustic scenes or flowers, inlaid, but never with the intimate skill of the French *ébénistes*. Lacquer, heavy gilding, mirrors, painted glass and combinations of other materials led to a bewildering and not always happy mixture of styles.

Left: Design from Ince and Mayhew's 'The Universal System of Household Furniture' (1759–68), English. Engraving. Above: Design by Thomas Johnson (1714–c.1778), 1758, English. Engraving. (Victoria and Albert Museum, London)

Outstanding in the art of inlay was Pietro Piffetti (1700–77), who worked for the House of Savoy at Turin, creating highly individual furniture combining wood and ivory inlays with such refinements in metal as masks at the corners and mounts for legs. The Royal Palace at Turin contains some breathtaking pieces, literally covered with ivory inlay and occasionally seeming to be supported solely by chance, so fragile are the legs beneath their overwhelmingly elaborate upper parts. In the Museo Civico in Turin is a card-table by Piffetti, stamped and dated 1758, with a wholly convincing *trompe l'œil* of playing-cards in ivory and rare woods.

In the minor arts nothing of great significance was produced in Italy compared with elsewhere in Europe, and certainly no ceramics factory appeared to rival that of Sèvres. But two factories produced porcelain, much of which is certainly very beautiful – Vinovo in Piedmont and Capodimonte outside Naples. Capodimonte porcelain is characterized by the brilliance of its colouring, often in unexpected combinations as seen in the famous Porcelain Room from the Palace at Portici (1754–59).

Turning to Venice once more, we find painting dominated towards the mid-century by Giambattista Tiepolo (1696–1770), and, slightly later, by his son, Giovanni Domenico Tiepolo (1727–1804). In the elder

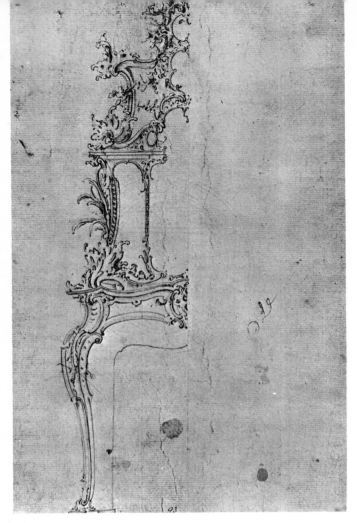

Design for furniture by Matthias Lock (active c.1740–69), English. Drawing. (Victoria and Albert Museum, London)

Tiepolo, and in him alone, can one speak of a pure rococo style, related to the late Baroque in many ways, but creating an entirely new type of visual experience. Not surprisingly, many of the greatest Venetian qualities from the past are present in his work: the colour and original imagination of Titian; the figure types and luxurious materials of Veronese, together with his love of opulent classical architecture as a backdrop for rich pageants of history and mythology.

The artificiality of the atmosphere in his early frescoes links Tiepolo at once with the mainstream of rococo art, but at a time when he could not have known much about contemporary French painting. From then on his career was a meteoric success until his eclipse in Madrid at the end of his life at the hands of the neoclassicists under Mengs.

His greatest commission came in 1750, when he went to Würzburg to paint frescoes for the newly completed palace there and stayed until 1753 to decorate the staircase (the largest fresco in the world), the Kaisersaal and the chapel. Shortly before leaving for Würzburg, Tiepolo had decorated the Palazzo Labia in Venice with the story of Anthony and Cleopatra, one of his most evocative recreations of classical histories.

A comparison of Tiepolo's style with that of his exact contemporary, Boucher, reveals a different and perhaps more intellectual temperament. His glacially elegant but still voluptuous nudes and his subtle juxtaposition of types, as in the Würzburg staircase where the 'Continents' are brilliantly contrasted, is more original and complex than anything by Boucher.

It was no accident that Boucher admired Tiepolo above all others; 'much more than Watteau's, his art is that of the theatre, with a stage that is deliberately elevated above us, and actors who keep their distance', says Michael Levey. Indeed his art is the last which is truly representative of aristocratic ideals, soon to be replaced by the republican values of the French Revolution, an art which could only have flourished in a city-state as decadent as Venice in the eighteenth century.

While Tiepolo, father and son, were the finest decorators in the city, there were the *vedutisti*, or view-painters, such as Canaletto (1697–1768), whose great fame brought him to England between 1746 and 1756.

The paintings of Francesco Guardi (1712–93) are triumphs of atmospheric study and understanding of the singular effects of Venetian light on water and architecture. With a minimal palette, reduced in some cases almost entirely to simple greens and greys, Guardi evokes landscape and views of the canals in much the same way that Tiepolo executes figures, and with magic dots of colour suggests people hurrying or engaged in conversation in the Piazza San Marco or any of the many squares of Venice which he so clearly loved.

Pietro Longhi (1702–85), in contrast, specialized in somewhat gauche renderings of contemporary life; in their gaucheness however lies their great charm, and in the often delightfully unexpected choice of subject such as the 'Rhinoceros' (National Gallery, London) or the 'Moorish Messenger' (Ca' Rezzonico, Venice).

But Italy was never as happy with the rococo style as it had been with the preceding style of the Baroque or that of Neoclassicism, both of them heavier and more capable of expressing the *grandezza* so beloved of Italian post-renaissance art. This, however, appears in Tiepolo in a modified form, and it is his name which remains outstanding.

The rococo style in England

Of all the European countries which had adopted or contributed to the baroque style, England was the one which paid least attention to the Rococo. In architecture, at least, England moved directly from the baroque style of Wren and Vanbrugh to Palladianism, a transition so swift that it allowed of no intermediate development. With buildings such as Walpole's Strawberry Hill, Twickenham, built from 1748, and Arbury, Warwickshire, of the same date and the other 'Gothick' buildings erected during the eighteenth century it is sentiment which places these works in the rococo category rather than any relationship with the *rocaille*.

In fact English Gothick is divided into two distinct categories – 'associational' and 'rococo', the latter being a light-hearted form of decoration loosely based on medieval precedents but frivolous enough to become almost a counterpart of Continental Rococo in its sense of abandon and superficiality. William Kent (1684–1748),

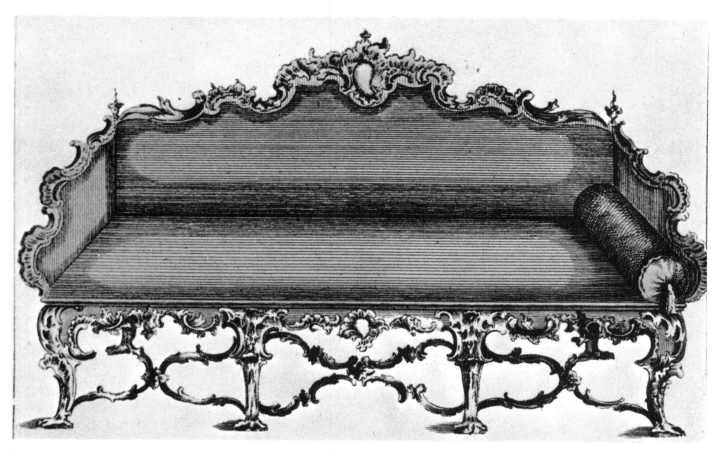

Design for a sofa by Franz Xaver Habermann, German. Engraving. (Victoria and Albert Museum, London)

architect and decorator, devized his own vocabulary of Gothick decoration, which spread as quickly and as effectively over England as the arabesques of Continental Rococo. But, apart from this, *rocaille* in England touched only a handful of interiors, some high-quality furniture, certain paintings and some porcelain, in particular the products of Chelsea and Bow.

The earliest example of *rocaille* in England was the commission given to the great French designer Meissonnier by the Duke of Kingston in 1735 for a suite of table furniture in silver. But this was a fairly rare instance and rococo design was generally confined to engraved decoration on sober forms almost entirely unaffected by the style. The new tendencies were purveyed predominantly by pattern-books such as Matthias Lock's, or Jones's 'The Gentleman's or Builder's Companion' of 1739, which made rococo or quasi-rococo details available to every craftsman who could afford the volume. The fact that these were only details, detached from their surroundings, accounts for the frequently gauche quality of much English rococo furniture, since the craftsman could not be expected to appreciate the organic nature of the style from mere fragments.

As in Italy and France, the eighteenth-century patron's taste often extended to the Oriental in one form or another, accounting for the few rococo rooms of note in England such as the bedroom at Nostell Priory, Yorkshire, of 1745, or, the most important, Claydon House in Buckingham-shire of *c.*1768, where a series of rooms were decorated by a certain Lightfoot, about whom little is known. In these rooms, however, the style is by no means as pure as Continental Rococo.

Rococo decorations appear in other English town and country house interiors and are sometimes of the highest quality – notably in the hall at Ragley, at nearby Hagley, and in the swirling plasterwork of the Francini brothers, who executed much stucco work in Ireland, and are particularly famed for their work at Russborough. But this attractive local craftsmanship is a far cry from the consummate, all-embracing schemes of the Continent.

Unlike the French, English cabinet-makers did not usually sign their pieces, and so comparatively little is known of men such as John Linnell, John Cobb, Benjamin Goodison and William Vile, who all appear to have worked extensively in the new fashion. The name of Chippendale is, however, outstanding, not only because of the quality of his pieces, but also because of his publication 'The Gentleman and Cabinet-maker's Director' (1754).

In his designs for mirrors and overmantels, often flavoured by *chinoiserie*, one sees exotic examples of the rococo style, every bit as meticulous as French *boiserie* but designed to be used as isolated features and rarely as part of a whole decorative scheme. Likewise, the elaborate and fantastic carvings in the hall at Claydon are isolated in an otherwise classical setting.

In painting, two English artists made certain concessions to the rococo – William Hogarth (1697–1764) and Thomas Gainsborough (1727–88). Hogarth reacted strongly against the type of baroque history painting which was so sought

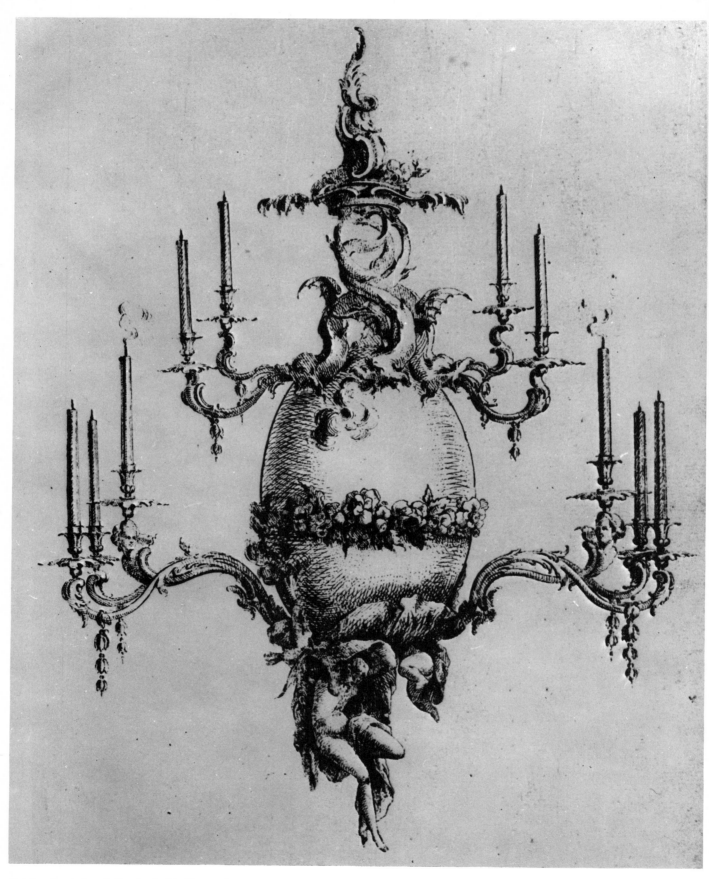

Design for a chandelier by J. M. Hoppenhaupt (1709–c.1755), German. Drawing. (Victoria and Albert Museum, London)

after by the 'amateurs' and introduced into his own work the so-called 'Line of Beauty', which he explained in his 'The Analysis of Beauty' (1753) and which was a serpentine line rather like an elongated 'S'. This was, of course, precisely the form of much rococo decoration.

Gainsborough, on the other hand, began life as a painter of small, stilted portraits later developing a more sophisticated style after his move to fashionable Bath. He painted some portraits in a rococo style surprisingly close to Boucher, their floating brushwork and feathery landscapes, bright pinks and silvery greys pronouncedly more rococo than any contemporary English painting.

Neoclassicism swept England from the return of Robert Adam to the country in 1758, but even his 'chaste and epicene style' echoes the dainty, meticulous quality of most French rococo decorations and his Gothick is as rococo as any decoration of that period in England.

The rococo style in Germany

In contrast to the superb restraint of the finest French rococo, Germany provides a breathtaking range of some of the most outrageous and magnificent rococo architecture and interior decoration in the history of European art.

This high standard of excellence spread from architecture to the applied arts – to furniture, furnishings and porcelain – though these rarely surpassed those of France. Nothing in eighteenth-century France, Italy or England rivals the sheer excess of such architectural masterpieces as Melk or the Dresden Zwinger, and in the number of first-rate churches and palaces alone, Germany easily outstrips the others. This may stem from the fact that what we now call Germany, was, in the eighteenth century, divided into several different principalities, kingdoms and bishoprics, so that a certain rivalry must have determined the creation of buildings of major importance . . . unlike France or England where the really important commissions were invariably confined to a small number of patrons.

German rococo can be seen to trace its origins to Roman churches of the baroque period such as Bernini's Sant'Andrea al Quirinale, where colour, light and elaborate sculpture are all combined. This is apparent for the first time in Germany in the Abbey Church of Weltenburg, built after 1714, with its oval dome cut away internally to reveal a frescoed vision of the heavens above.

Colour was the main string to the bow of German rococo – pink, lilac, lemon, blue – all were combined or used individually to telling effect, as in the Amalienburg, near Munich. The heavier, curving forms of the Baroque are turned into more *staccato* rhythms in German rococo, and one finds the influence of a major baroque monument such as Bernini's *baldacchino* in St. Peter's Rome, transformed by J. Balthasar Neumann (1687–1753), into a confection of the order of the high altar at Vierzehnheiligen, perhaps the most complex and satisfying of German churches.

While room shapes in France during the eighteenth century did not change a great deal, and the plan of ecclesiastical buildings hardly at all, German rococo architects explored every possibility. Walls not only seem to sway despite their huge scale, but whole sections appear to have been cut away, with the effect that the enormous frescoed ceilings, which entirely dominate most of these churches, seem to float above the worshipper.

One of the most exciting features of German rococo architecture is the highly dramatic siting of some of the most important examples, such as the Abbey of Melk by J. Prandtauer, begun in 1702. Deliberately placed in a commanding position high above the Danube, the two great towers dominate a courtyard in front opened to the outside world by a great Palladian-type arch. Such a feeling for drama, and for the total involvement of the faithful both externally and internally, is also found at Ettal, in a reversed role, with the monastery dominated by surrounding mountains.

Secular building also reached a high level of perfection. Perhaps the most sophisticated examples are to be found in and around Munich where, as court dwarf and architect, François Cuvilliés (1695–1768) was involved in many buildings, perhaps the finest being the Amalienburg. This small *pavillon*, built between 1734 and 1739 and named after the Elector's wife, has, in Hugh Honour's words, 'an easy elegance and gossamer delicacy'. Its gently swaying front, shallow rustication and unusual pediments herald one of the loveliest rooms in Europe – the famous Hall of Mirrors with its silver *rocaille* against powder-blue background and glittering glass. At the opposite end of the scale, Cuvilliés' Residenz-theater in Munich (1751–53) uses richly gilded figures and musical instruments to frame the entire auditorium, contrasting vividly with the red damask and velvet of the walls and seats.

Potsdam and Dresden never produced a rococo style as refined as that of Munich, but buildings such as the Zwinger (1709–19) by Pöppelmann in Dresden overwhelm by their scale and superabundance of decorative detail. The effect of this type of architecture is also felt in the little Palace of Sans Souci at Potsdam (1745–51), which was built for Frederick the Great.

For sheer scale, opulence and overpowering grandeur of detail, the Rococo of Germany is foremost in Europe.

Later manifestations

The rococo style never really died out in provincial France. With the arrival of Historicism in the 1820s, many craftsmen found it comparatively easy to produce whole interiors and buildings in the 'Second Rococo' style so favoured by Louis Phillipe and his queen, examples of which are to be found throughout Paris.

The rococo revival came to England as early as 1828 with Wyatville's Waterloo Chamber in Apsley House, the interiors of Lancaster House and the Elizabeth Saloon at Belvoir Castle. It appealed naturally to the rich of the day, and the Rothschilds decorated several houses in the style, even incorporating actual eighteenth-century interiors at Waddesdon Manor in the 1880s.

Royal assent was given to the style by Ludwig of Bavaria in his Linderhof Palace and Herrenchiemsee of the same period. It became the accepted taste in the decoration of the many new hotels of the late nineteenth and early twentieth centuries and 'le gout Ritz' was to be synonymous with luxury and elegance.

Biographies

Boucher, François (1703–70)
French rococo painter and decorator and protégé of Madame de Pompadour, Louis XV's mistress. Won the Prix de Rome in 1723 and became Director of the Academy in 1765, exerting an important influence on French art.

Cressent, Charles (1685–1768)
Great French *ébéniste* of the rococo period, trained as a sculptor. Involved in disputes with the *fondeurs-ciseleurs* for casting his own mounts, for which his early work is renowned. Turned eventually to floral marquetry. Died in poverty.

Cuvilliés, François (1695–1768)
German architect and court dwarf in Munich. His designs in the rococo manner published from 1738. Architect of the Amalienburg in the grounds of Nymphenburg, famed for its hall of mirrors, and of the Residenz-theater, Munich.

Linnell, John (died 1796)
English cabinet-maker, carver and upholsterer. Worked in the period dominated by Chippendale and later by the Adam brothers adopting and adapting their styles.

Meissonnier, Juste-Aurèle (1695–1750)
French goldsmith and ornamentalist born in Turin. Became *dessinateur du cabinet du roi* in 1726. His designs for silver and porcelain were known throughout Europe – at Chelsea and Bow, for example. Advocated asymmetry, a distinctive rococo feature.

Neumann, Johann Balthasar (1687–1753)
German architect and brilliant exponent of the baroque style whose immense practice in south Germany consisted mainly of large houses, monasteries and churches. His great works include the church at Vierzehnheiligen and the castle at Brühl near Cologne.

Oeben, Jean-François (c.1720–63)
German cabinet-maker who settled in Paris in the 1740s. Established by the patronage of Madame de Pompadour. Became a *maître ébéniste* in 1761. Famed for his elaborate marquetry and mechanical pieces.

Oppenordt, Gilles-Marie (1672–1742)
French architect, draughtsman and ornamentalist, who had a particularly strong influence on the furniture of Cressent. Best known for his engraved designs for wrought ironwork. Worked for the Duc d'Orléans.

Pifetti, Pietro (1700–77)
Italian furniture-maker employed at the Court of Victor Amadeus II in Turin. Famous for his delicate inlays of ivory, mother of pearl and ebony.

Pineau, Nicolas (1684–1754)
French architect and designer and an early and important influence on the rococo movement. Worked in Russia, returning to Paris in 1726.

Riesener, Jean-Henri (1734–1806)
German *ébéniste* who established himself in Paris by marrying Oeben's widow. Completed the famous *bureau du roi* begun by Oeben. In 1774 appointed *ébéniste ordinaire* to Louis XVI. Supplied some of the most costly pieces made in the eighteenth century.

Tiepolo, Giambattista (1696–1770)
Italian painter, the last of the great Venetian decorators and the purest exponent of the Italian Rococo.

Vile, William (died 1767)
English furniture-maker, partner of John Cobb and a royal cabinet-maker. The cabinet-pieces supplied by their firm to George III and Queen Charlotte are still at Buckingham Palace and many are representative of the fashionable Rococo.

Watteau, Antoine (1684–1721)
Flemish painter and designer working in Paris after about 1702. His paintings, often reflecting the lyrical mood of the Rococo, were much influenced by Rubens and the Venetians; they were used in the decoration of rococo porcelain. His designs for arabesques were the inspiration for many craftsmen.

Bibliography

Bazin, G., *Baroque and Rococo*, Thames and Hudson, London 1964
Brunhammer, Y., 'The Eighteenth Century, France' in *World Furniture*, Paul Hamlyn, London 1965
Hayward, H., 'Baroque and Rococo' in *Great Interiors*, Weidenfeld and Nicolson, London 1967
Honour, H., *Chinoiserie. The Vision of Cathay*, John Murray, London 1961
Levey, M., *Rococo to Revolution*, Thames and Hudson, London 1966
Pignatti, T., *Il Rococo*, Fabbri, Milan 1966
Praz, M., *An Illustrated History of Interior Decoration*, Thames and Hudson, London 1964
Sitwell, S., (editor), *Great Houses of Europe*, Weidenfeld and Nicolson, London 1961
Verlet, P., *French Furniture and Interior Decoration of the 18th Century*, Barrie and Rockliff, London 1967

Acknowledgements are due to the following for photographs used in this volume:
Ashmolean Museum, Oxford: 69, 70, 71. B.P.C. Publishing Limited, London: 14, 15, 16, 17, 18, 19, 20, 21, 23, 24, 25, 38, 41, 42, 48, 49, 58, 59, 60, 65, 66, 73, 75, 77. J. Cannings: 61. Capodimonte Museum, Naples: 10. Connaissance des Arts, Paris: 1, 2, 3, 35, 45. Claude Esparcieux: 27. Flammarion, Paris: 5. J. Freeman: 26, 30, 32, 33, 43, 62, 63, 64, 76. M. B. Garvan Collection, Yale University Art Gallery, New Haven: 78, 79. Michael Holford Library, London: 6. By gracious permission of H.M. The Queen: 34, 37. Istituto Geografico De Agostini, Novara: 11, 12, 13, 47, 50, 51, 52, 53, 54, 55, 56, 67, 68. Metropolitan Museum of Art, New York: 28. Musée du Louvre, Paris: 36. P. Parkinson: 72. George Rainbird Limited, London: 57. Residenzmuseum, Munich: 40. Rijksmuseum, Amsterdam: 39. Scala, Florence: 8, 9. Service de Documentation Photographique, Paris: 44. Edwin Smith: 7. Worshipful Company of Goldsmiths, London: 74.

1 *La Grande Singerie* at the Musée Condé, Chantilly, decorated by Christophe Huet (died 1799). *c.*1730. Monkeys wearing the livery of the Prince de Condé are depicted taking part in tea-parties, hunting-scenes and other human activities in the wall-panels, and in their natural habitat on the ceiling. *Singeries* were popular, particularly in France, in the eighteenth century and, as at Chantilly, they were often combined with *chinoiserie* motifs. They first occur in the designs of Jean Bérain (1639–1711) and were taken up by the painter Watteau, to whom the decoration of this room was once attributed. An especially elegant example of a French rococo interior, La Grande Singerie illustrates the lightness and inventiveness that characterizes the style.

1

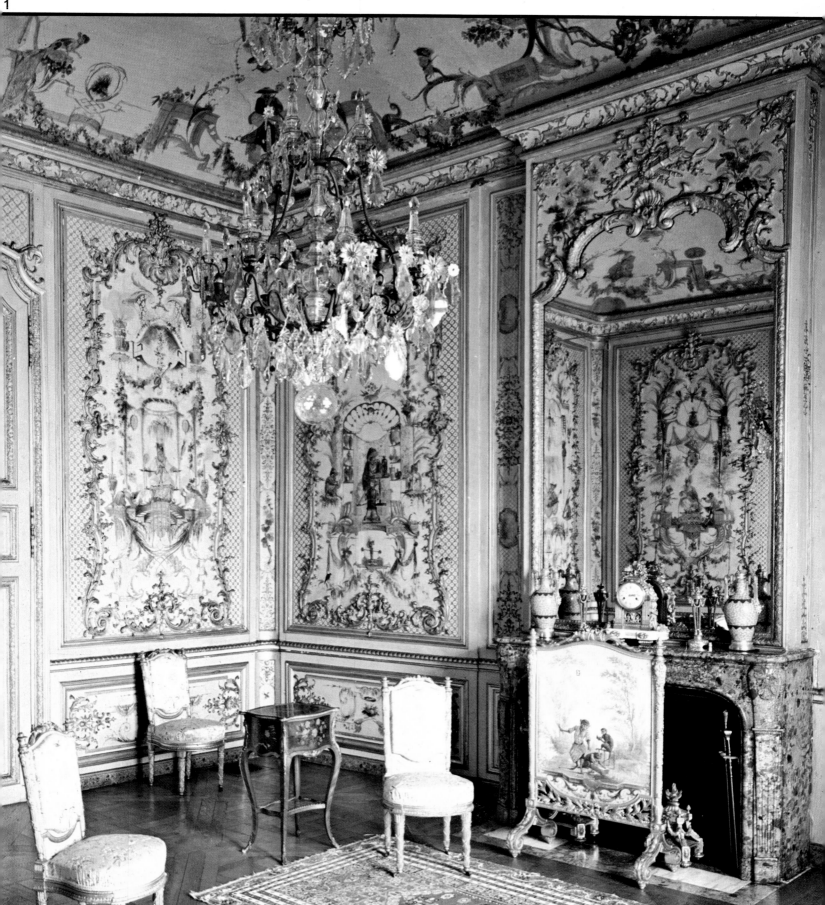

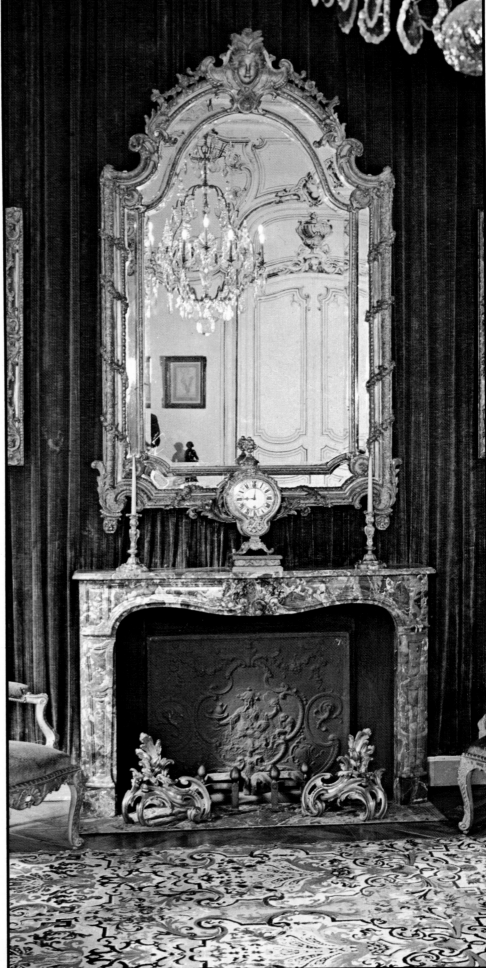

2 *Looking-glass* in the style of the Régence period (Barroux Collection). The Duc d'Orléans acted as Regent of France from the death of Louis XIV in 1715 to 1723 when Louis XV attained his majority and succeeded to the throne. The Régence style was one of transition from the Baroque to the Rococo and elements of both may be seen in this looking-glass, with its symmetry and lightness of detail. The development of sheet-glass manufacture in Paris at the end of the seventeenth century made possible the production of the looking-glass, providing the rococo style with a highly decorative and spatially ambiguous effect.

3 *Salon* in a private house, France. This drawing-room with its original eighteenth-century panelling and furniture, which still exists in a private house, shows the typical disposition of an elaborate marble-topped console-table under a pier-glass flanked by two armchairs.

4 *Salon Chinois in the Château de Champs*, acquired by Madame de Pompadour in 1757. Christophe Huet (died 1799) was employed to add the *chinoiserie* decoration, the painted panels of arabesques providing a composite scheme of decoration. In so far as the internal comfort and amenities of the Château de Champs were quite remarkable in a building of that period, it broke new ground in a direction that was to be followed by almost all eighteenth-century *châteaux*.

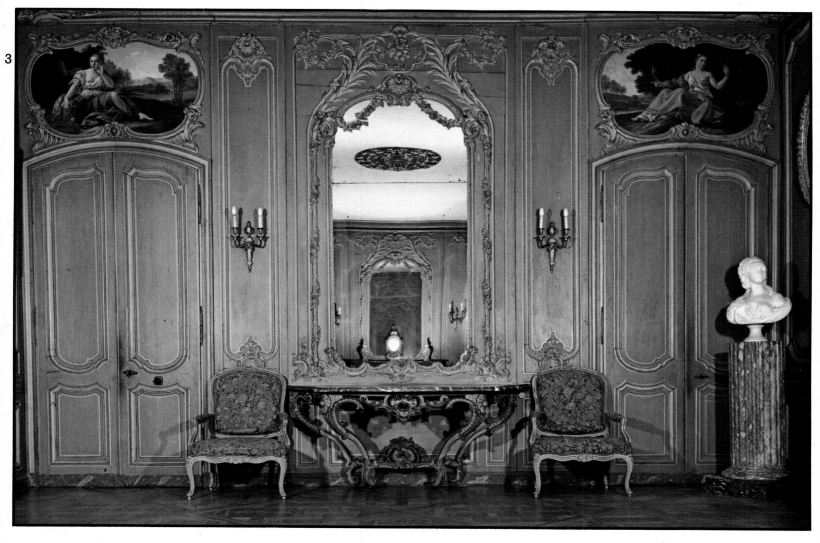

3

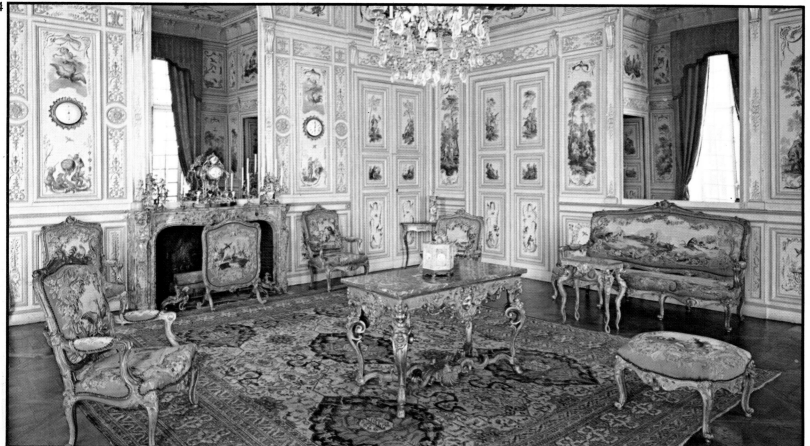

4

5 *Le Petit Déjeuner* (detail) by François Boucher (1703–70). 1739. (Louvre, Paris.) François Boucher became Director of the French Academy in 1765 and made a highly important contribution to the rococo movement through his many paintings and his designs for tapestries and other decorations. This domestic scene showing an elegant console-table to the left and elaborate candle-holders flanking the looking-glass, only part of which are visible in this detail, demonstrates that rococo furniture was as well suited to the bourgeois style of life as to the palatial existence of the aristocracy.

6 *Spiegelsaal* (Hall of Mirrors) in the Amalienburg, designed by François Cuvilliés (1698–1767) and built between 1734 and 1739. Glittering in ice-blue and silver, the Hall of Mirrors is the focal point of the Amalienburg. The use of mirrors for lightening the appearance of reception rooms had been quite common since Versailles, but rarely were they employed to such magnificent effect and in such essentially intimate surroundings.

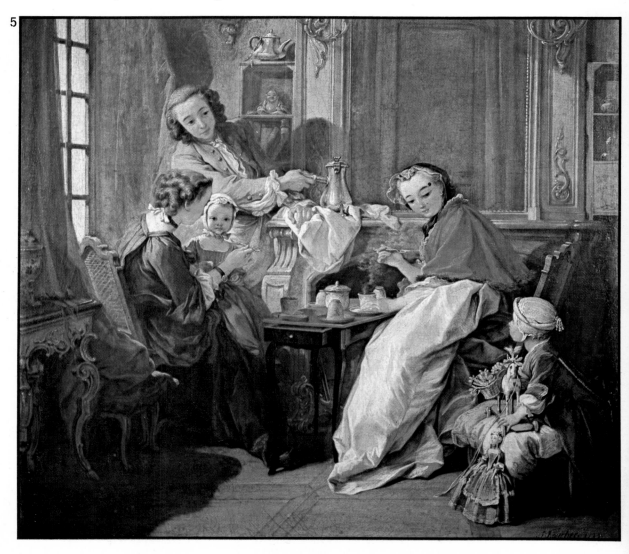
5

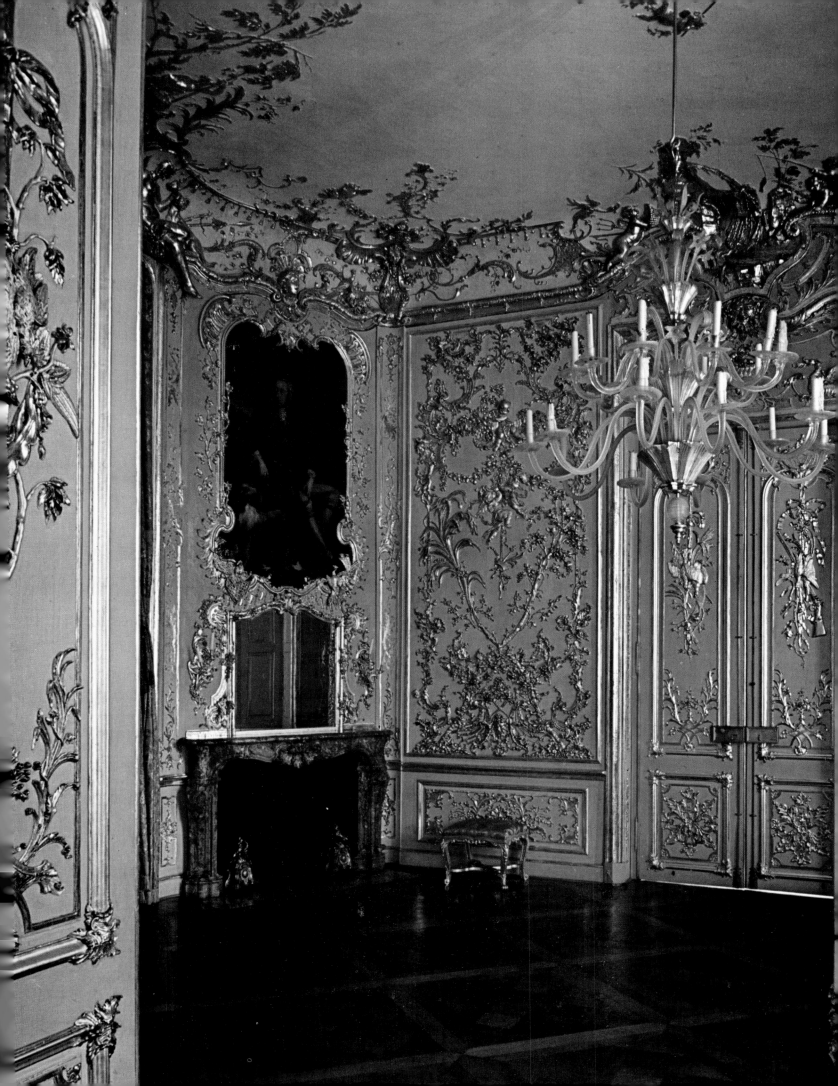

7

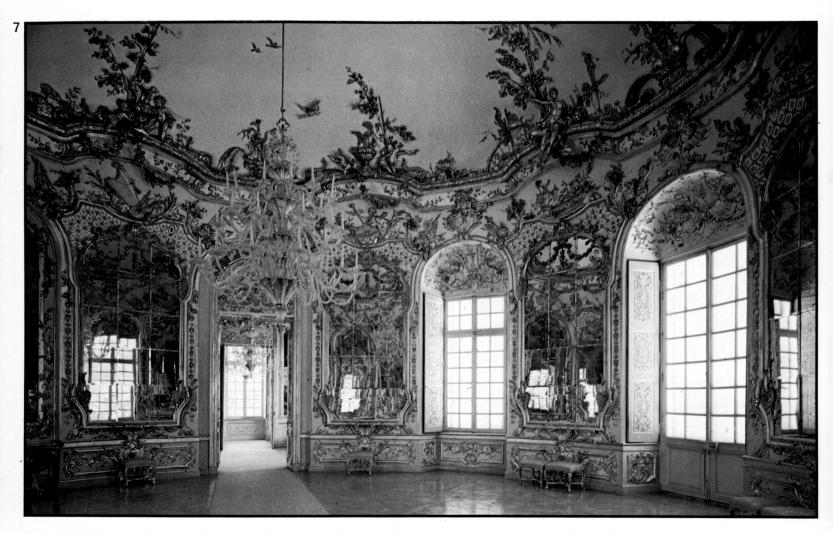

7 *Interior of the Amalienburg*, view of the bedroom from the Spiegelsaal (Hall of Mirrors) designed by François Cuvilliés. Cuvilliés, one of the major exponents of the rococo style was born in Hainault. He was sent to Paris by the Elector Maximilian Emanuel of Bavaria to be trained under François Blondel. Returning to Munich in 1725, he was appointed Court Architect and carried out extensive architectural and decorative schemes in the official buildings of Bavaria. With the Amalienburg, in the park of the Schloss Nymphenburg, not far from Munich, Cuvilliés and the Zimmermann brothers created the masterpiece of Bavarian Rococo.

8 *Porcelain room* from the Aranjuez Palace near Madrid, designed and decorated by Joseph Gricci, for Charles III of Spain, begun shortly after the opening of the Buen Retiro factory in 1760 and completed in 1765. Similar in manner to the porcelain room at Portici, now at Capodimonte, this extraordinary room, profusely decorated with figures in animated conversation and romping monkeys, has a unique life and vigour. Gricci recreated the naive rococo vision of the Orient, possibly influenced by the *chinoiserie* frescoes of Tiepolo that were to be seen in Madrid. The porcelain materials used here were probably brought from Naples. The cost of this room was 571,555 reales.

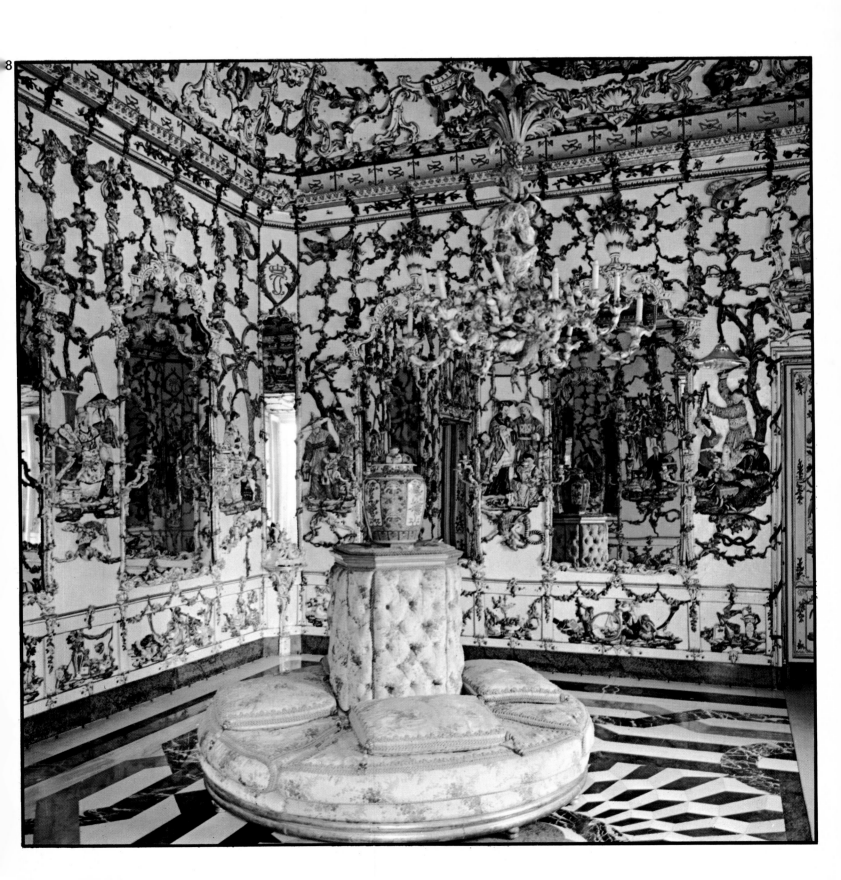

9

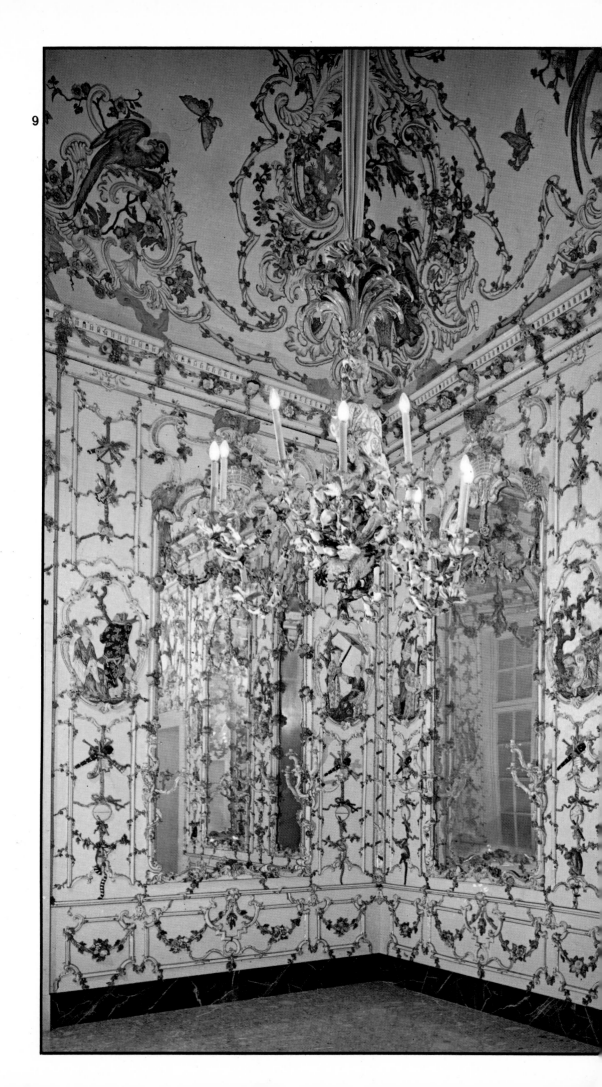

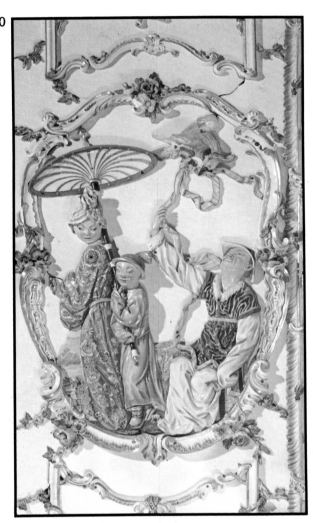

9 *Porcelain room* from the palace at Portici, Naples. 1757–59. Under the patronage of the Bourbon King of Naples, Charles III, a porcelain factory was set up at Capodimonte. The porcelain decorations of this room in the *chinoiserie* style cost seventy thousand ducats to complete: they were probably designed and executed by the Grico (later Gricci) brothers. Despite the elaboration and complexity of the scheme, the room retains a lightweight elegance characteristic of the rococo style.

10 *Chinese figures* from the porcelain room of the palace at Portici. The Chinese taste of the mid-eighteenth century is a European phenomenon typical of the rococo disregard for the classical heritage. Contact with the Orient had led at first to the simulation and eventually to the imitation of its porcelain, a material which became during the eighteenth century almost as much a status symbol among European monarchs as gold. The porcelain fruit and flowers among these decorations are rendered with a fresh naturalism which can be related to the contemporary thinking of J.-J. Rousseau and *Les Philosophes.*

11

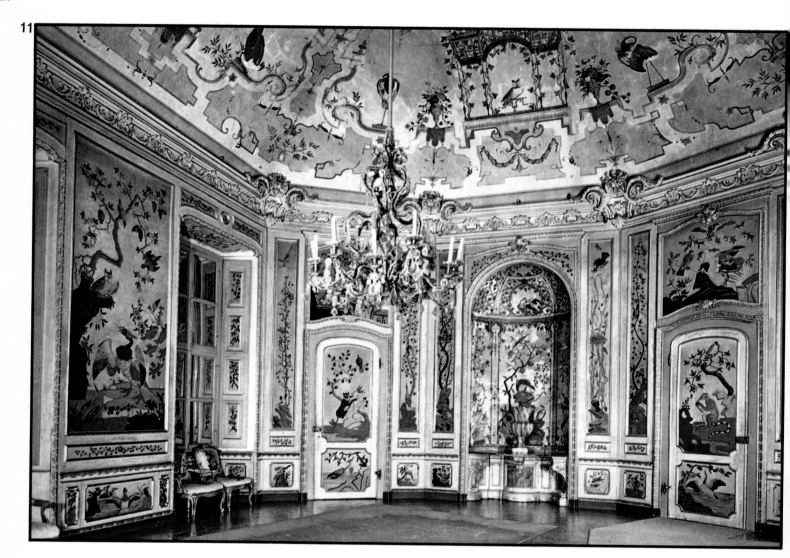

11 *Games-room* of the hunting-lodge at the Castle of Stupinigi. The Oriental flavour of the ceiling decorations, painted by Pozzo in 1765, have been translated into a more Western setting. There are strong echoes from the grotesque decorations in the Vatican apartments carried out by Raphael and his studio.

12 *Chinese room* in the Palazzo Reale, Turin. The architect, Filippo Juvarra (1676–1736) designed this room, incorporating panels of Chinese lacquer in carved and gilt-wood frames. The importance of Chinese decorative work to the rococo style can be gauged by the extent to which the lacquer panels blend with the *rocaille* motifs of the woodwork. The decoration of the room was carried out between 1735 and 1738. If the colour scheme of red, black and gold give the room a formality which was old-fashioned, the profusion of curves and the freedom of the decoration from any architectural role were more up-to-date.

13 *Room of painted silk* in the hunting-lodge at Stupinigi, near Turin. The informality and lightness of the painted pattern on the silk wall-coverings are a far cry from the heavy didacticism of baroque fresco paintings. For his work at this hunting-lodge (1729–33), the church of the Carmine in Turin (1732–35), and the sanctuary of the Superga near Turin (1717–31), Juvarra may be counted among the great architectural talents of his age.

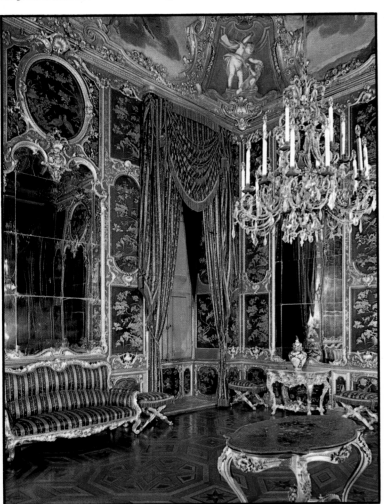

13

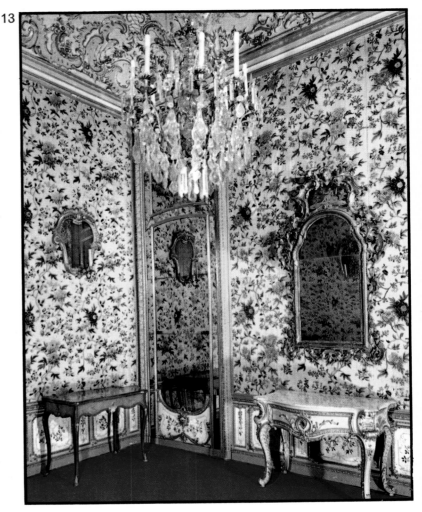

14

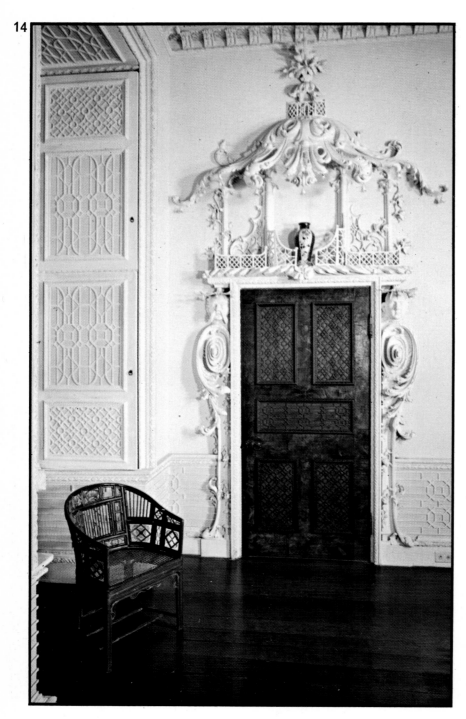

15

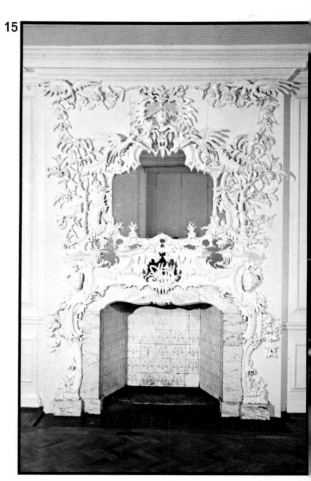

16

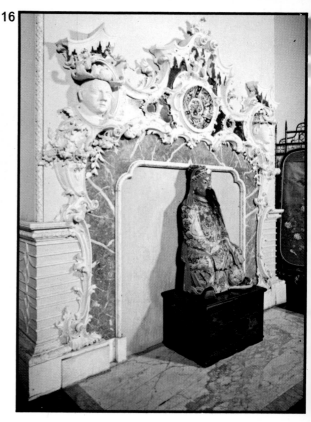

14 *Doorway in the Chinese Room at Claydon House*, Buckinghamshire. This room, although quite moderate in size and unpretentious in the cost of its ornament, is one of the most consistent *chinoiserie* decorative schemes in Europe. It was conceived by the second Earl Verney, designed by Luke Lightfoot and executed in carved wood as opposed to the plaster of much rococo decoration.

15 *Fireplace at Stedcombe Manor*, Devon. This carved wood and marble fireplace combined with a looking-glass frame above is made to a design by Matthias Lock which appears in Lock and Copland's 'A New Book of Ornaments' (1752). Lock was unusual among English designers in his fidelity to the spirit of Continental, particularly French, Rococo. Hubert François Gravelot (1699–1773) was a French artist who arrived in England in 1732 and undoubtedly played an important part in the dissemination of the work of such great French *ornémanistes* as Pineau and Meissonnier; but apart from Lock, few English artists managed to express in their design the feeling of wit and sophistication which pervades French rococo decoration.

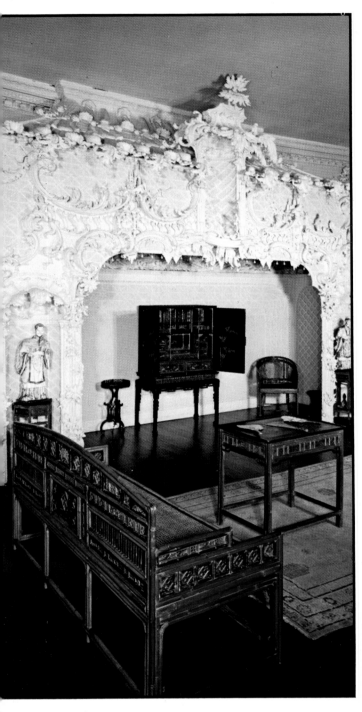

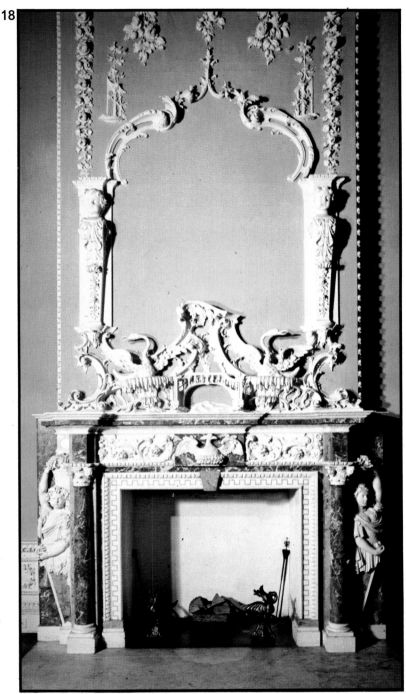

16 *Fireplace in the dining-room of Claydon House*, Buckinghamshire. This *chinoiserie* fireplace was designed by Luke Lightfoot, probably in the 1750s. It is of carved wood. As well as a fireplace, it serves as an elaborate setting for a particularly fine piece of Chinese porcelain. Porcelain, both from the Orient and the West, was a key material during the rococo period, its exotic qualities complementing the spirit of the decorative schemes.

17 *Alcove in the Chinese Room at Claydon House*, Buckinghamshire. *Chinoiserie* decoration was not as common in England as on the Continent. Lord Burlington and the orthodox Palladians tended to regard it with disfavour, but most decorators and cabinet-makers, including Chippendale, would turn their hand to it if their patrons required. The furniture in this room at Claydon demonstrates the English preoccupation with motifs rather than style; the chairs and table echo Chinese ornament rather than express true rococo *chinoiserie*.

18 *Fireplace in the North Hall of Claydon House*, Buckinghamshire. 1750s. The quality of the carving of these wooden fireplaces at Claydon matches the originality of their invention, and makes them exceptional among English rococo decoration, placing Lightfoot on a level with Grinling Gibbons.

19 *Design for the side of a room* by John Linnell (*c.*1737–96). *c.*1755–60. (Victoria and Albert Museum, London.) This drawing shows how English designers general⸢y⸣ superimposed elements in the rococo style on to traditional schemes of domestic architecture. By the middle of the eighteenth century the prevailing architectural style wa⸢s⸣ Palladian and there were few patrons who would desert its canons, except occasionally in decorative schemes. The china-stand incorporating a clock and surmounted by th⸢e⸣ figure of a *putto* armed with a scythe shows Linnell's power of invention. But there is a lack of urbanity in his work which distinguishes it from that of the more sophisticate⸢d⸣ French designers, even when they affect rusticity.

19

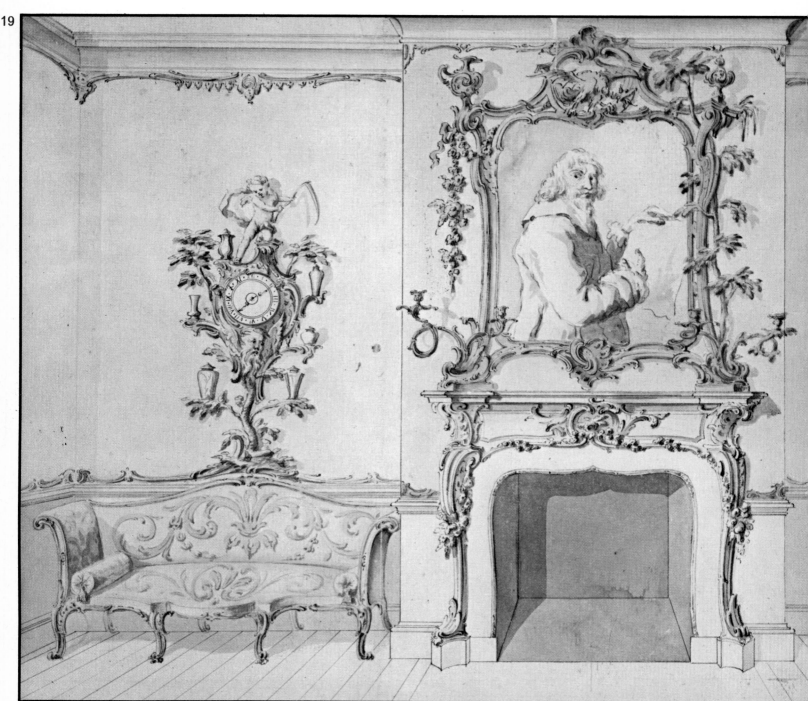

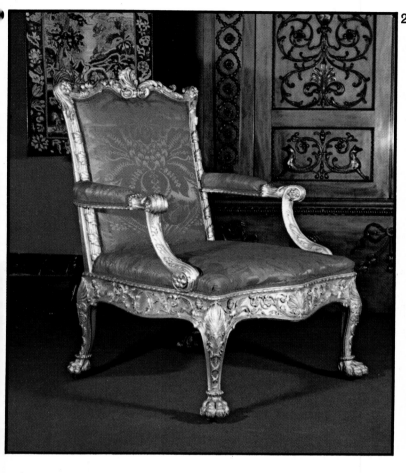

21

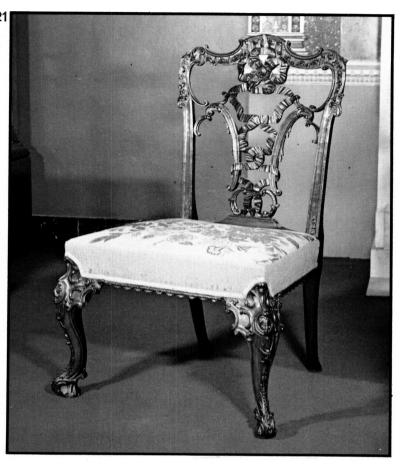

22

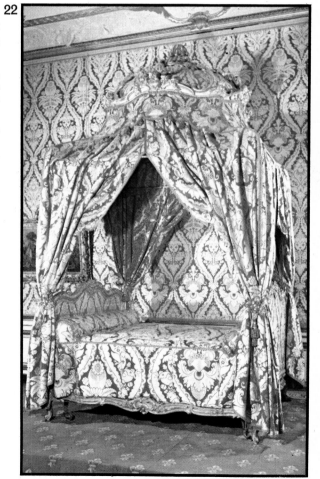

20 *Armchair* designed by Robert Adam (1728–92) and made by Thomas Chippendale (1718–79). 1764. (Victoria and Albert Museum, London.) Although the curves and scrolls of this chair are in the tradition of the English rococo designers, the Egyptian motifs – palmettes, sphinxes, lions' paws – represent a new spirit of archaeological interest which characterized the work of Adam and his followers. The chair was originally part of a suite of ten chairs and three sofas made for Sir Lawrence Dundas.

21 *A ribband-back chair* from a design in Chippendale's 'The Gentleman and Cabinet-Maker's Director' (Victoria and Albert Museum, London). The manner in which the ornament is concentrated on the front legs and on the back of this chair is typical of the English Rococo. French designers tended to give the entire form an overall ornamental treatment.

22 *Bed à la polonaise* by Nicholas Heurtant (1720–71). (Versailles.) In France at this period beds were made by *menuisiers* rather than *ébénistes*, but they often achieved a high degree of sophistication. Heurtant was one of the great *menuisiers* working in the rococo style. A la polonaise was the name given to this style of bed in honour of Marie Leczinska, the Polish wife of Louis XV.

23 *Bed* made by John Linnell (*c.*1737–96) for Badminton House, Gloucestershire. Early 1750s. (Victoria and Albert Museum, London.) At the end of the first half of the eighteenth century the taste for the Rococo in England focused equally on French *rocaille*, the Gothick and *Chinoiserie*, each providing a repertoire of structural and ornamental forms which were treated in the same fanciful way. The culmination of a number of pattern-books appearing in the 1740s and early '50s was Thomas Chippendale's 'The Gentleman and Cabinet-Maker's Director' (1754). The bed was a personal invention of one of the more talented English eighteenth-century designers.

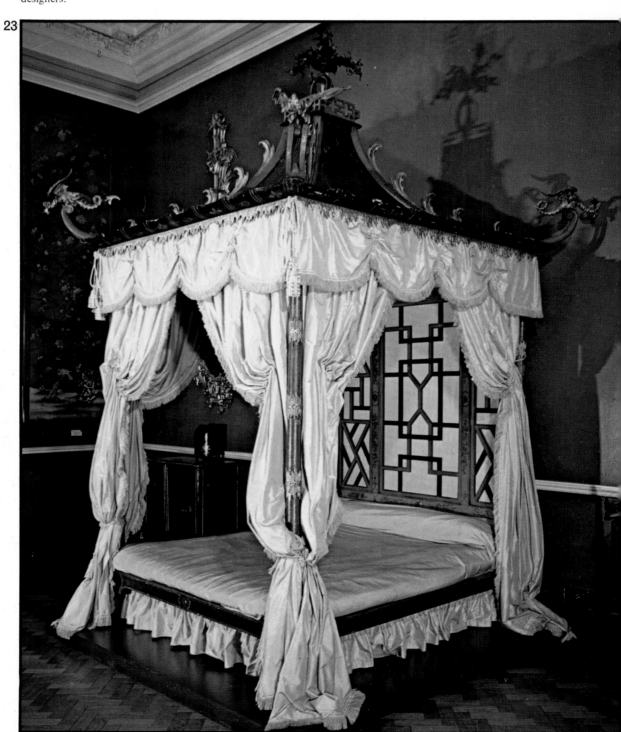

23

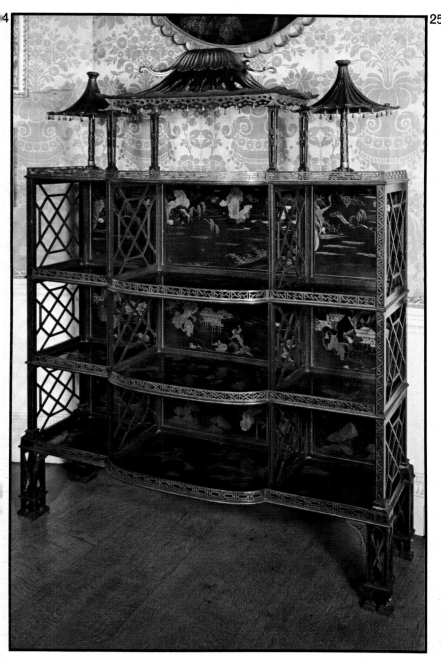

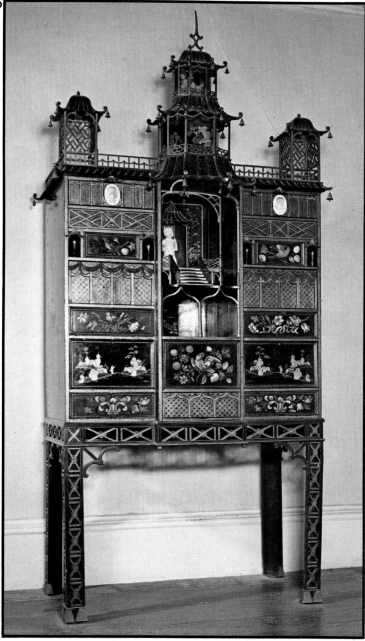

24 *Standing shelves* with pagoda decorations. (Kedleston Hall, Derbyshire.) The design of these shelves is based on a drawing in the 1762 edition of Chippendale's 'Director'. Fretwork was an aspect of Chinese design which the English designers particularly liked to exploit; it achieves a lightness in appearance which is one of the most marked characteristics of the Rococo. The sombre monumentality of the Baroque has been banished.

25 *Cabinet* in the manner of designs by Thomas Chippendale. (Uppark, Sussex.) Although this *chinoiserie* piece is decorated with panels of Oriental lacquerwork, it is also adorned with Italian *pietre dure* and carved ivory medallions of Homer and Brutus. The lack of interest in stylistic consistency of the eighteenth-century *cognoscenti* is well represented in this piece.

26

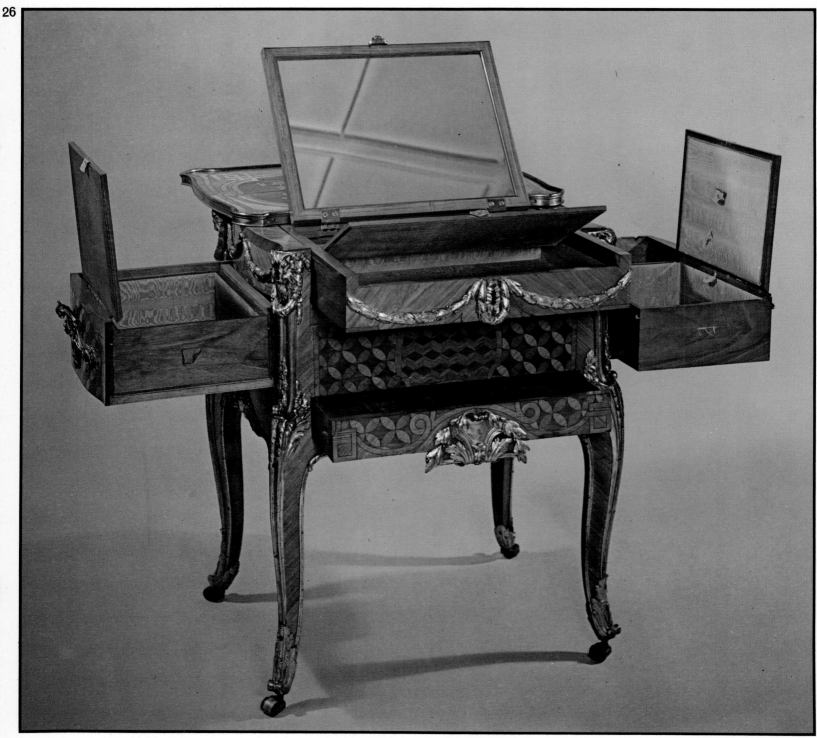

26 *Writing- and toilet-table* by J. F. Oeben (1720–63). (Wallace Collection, London.) Oeben was a German cabinet-maker who settled in Paris. He is famous for his marquetry work and for the ingenious mechanical devices he used in his furniture. The functions combined in this piece place it within the sphere of the Rococo, although the rams' heads and festoons of its ormolu mounts suggest the imminent advent of Neoclassicism.

27 *Commode* made by André-Charles Boulle (1642–1732) for Louis XIV's bedroom in the Grand Trianon and delivered in 1708. (Grand Trianon, Versailles.) This is a key piece; it is the earliest commode, a type of furniture which combined elements of the desk and the chest. Furthermore, the elaboration of its marquetry decoration and its swelling, almost *bombé*, curves heralded the Rococo.

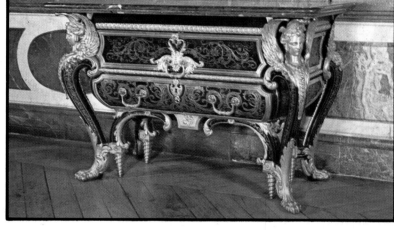

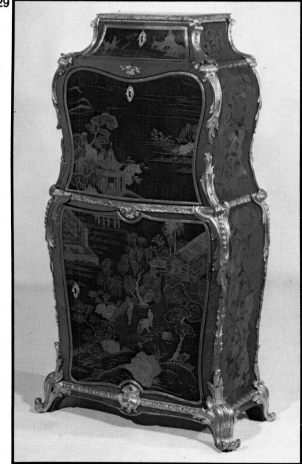

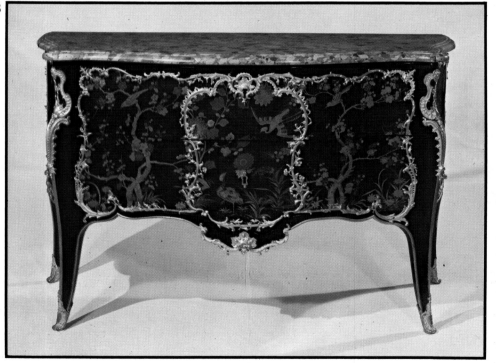

28 *Commode* by Bernard van Riesenburgh (died *c.*1765). Mid-eighteenth century. (Metropolitan Museum of Art, New York. Collection of Mr. and Mrs. Charles B. Wrightsman.) This piece is decorated with *vernis Martin*, a varnish the French produced as a substitute for Oriental lacquer. Van Riesenburgh, the second in a line of three cabinet-makers of that name, employed a wide range of ornamental techniques, introducing the use of Sèvres porcelain plaques in the decoration of furniture. The ormolu mounts were possibly modelled by his son.

29 *Drop-front secretaire* by Jean-Francois Dubut (died 1778). Mid-eighteenth century. (Metropolitan Museum of Art, New York. Collection of Mr. and Mrs. Charles B. Wrightsman.) This rococo form of the secretaire was to remain popular for two centuries.

30 *Corner-cupboard*, one of a pair by Jacques Dubois (1693–1763). (Wallace Collection, London.) Many rococo elements appear in the design of the ormolu mounts on this piece: *chinoiseries*, tendrils, the mask of Diana and the scythe and wheat emblematic of husbandry.

31 *Commode* by Pierre II Migeon. (Musée des Arts Décoratifs, Paris.) The two drawer-fronts have been treated as a single area for the purposes of decoration, the usual practice among rococo *ébénistes*. The lacquer-work is French rather than Oriental, but was probably copied from a Chinese original. A dynasty of cabinet-makers shared the name of Pierre Migeon. Pierre II Migeon was the most successful, enjoying the favour of Madame de Pompadour. He was a dealer as well as a cabinet-maker, employing over forty craftsmen.

32 *Commode* by Charles Cressent (1685–1768). (Wallace Collection, London.) Of the surviving commodes by Cressent, this one is the richest and the most famous. It dates from *c*.1730 and is one of the greatest achievements of Régence Rococo. The curve of the front is a form which was invented by Cressent, and is known as *un arc d'arbalète* (crossbow). Cressent laid great emphasis on his mounts, which he not only designed but also cast and chased himself; he was originally trained as a sculptor.

30
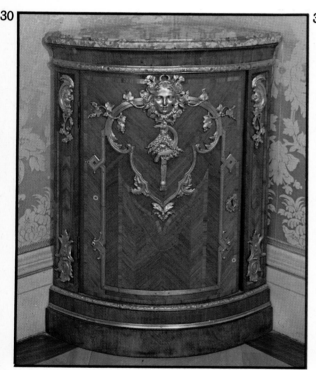

31
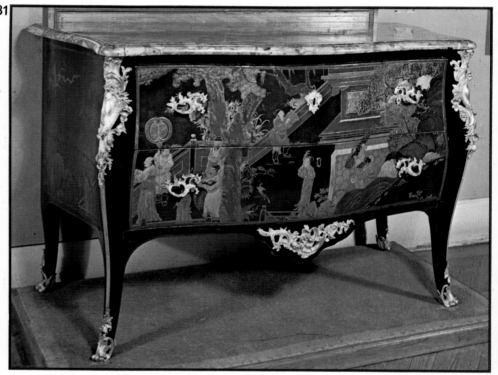

32
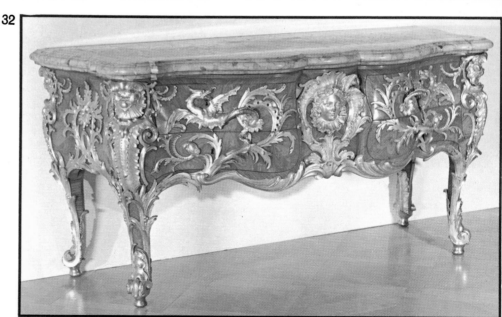

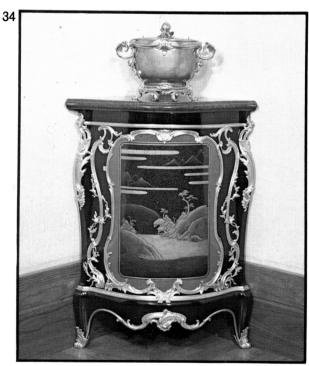

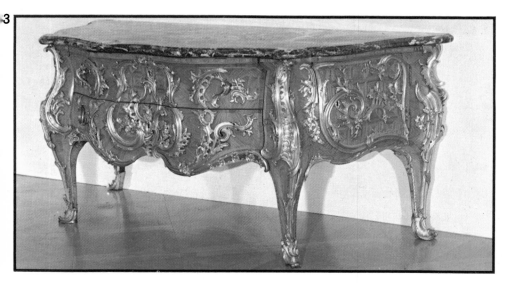

33 *Commode* by Antoine-Robert Gaudreau after a design by the Slodtz brothers, made for Louis XV. 1739. (Wallace Collection, London.) This magnificent commode, with its fine ormolu mounts designed by Jacques Caffiéri, stood in the King's bedroom until his death in 1774, by which date the *bombé* line and the scrolls of the mounts were somewhat out of fashion, proof of the King's long-standing predilection for the style. Louis XV never really took to any style but the true Rococo.

34 *Corner cupboard* by Bernard van Riesenburgh (died *c*.1765). Mid-eighteenth century. (By gracious permission of H.M. Queen Elizabeth II.) This small cupboard, set with a fine Japanese lacquer panel, has all the urbanity and panache for which Van Riesenburgh was justly famous.

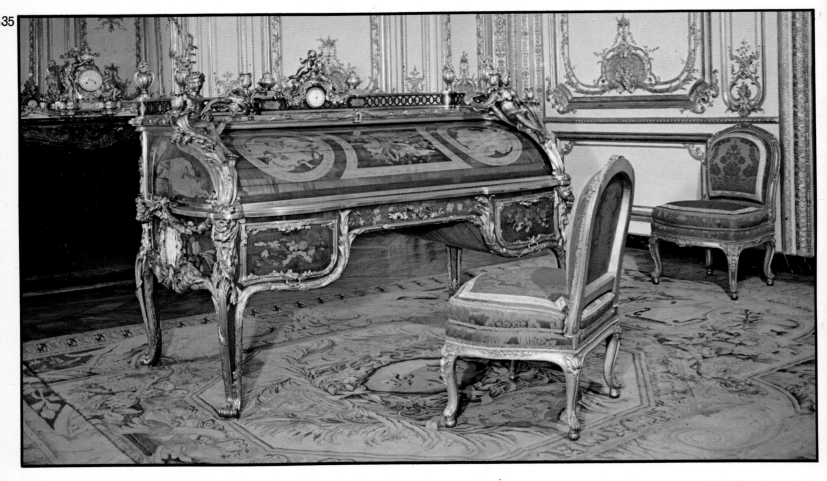

35

35 *Bureau du Roi*, a roll-top desk made for Louis XV by J. F. Oeben (1720–63) and completed after Oeben's death by J. H. Riesener (1734–1806), who executed the marquetry. (Versailles.) This piece in many ways represents the apogee of French rococo furniture, although its monumentality recalls the age of Louis XIV. The desk provided forms and motifs for many generations of neo-rococo stylists. One turn of the key in the lock released both the roll-top and the drawers. A subtle device is also incorporated which allows the ink-wells to be filled without the desk being unlocked.

36 *Bureau plat* by Charles Cressent (1685–1768). *c.*1730. (Louvre, Paris.) The flat desk form had been introduced by Boulle but this example by Cressent derives little else from that master. The use of light, exotic woods was a particular feature of Cressent's furniture. The ormolu mounts are designed with an inventive elegance which matches the piece's weightless proportions. One of the achievements of Cressent's work was the liberation of ornament from structure to which it had been subordinated during the baroque era.

37 *Commode* by Bernard van Riesenburgh (died *c.*1765) set with Japanese lacquer panels. (By gracious permission of H.M. Queen Elizabeth II.) This piece bears a Van-Riesenburgh hallmark – the thin rib of ormolu running along the contours of the commode. The silhouette effect thus achieved adds to the elegance of his designs. Van Riesenburgh's identity was only established in 1957; now he must be ranked among the greatest *ébénistes* of eighteenth-century France. His contemporaries prized his work so much that in sale-room catalogues his christian name was given – an honour bestowed otherwise only on Oeben and Cressent.

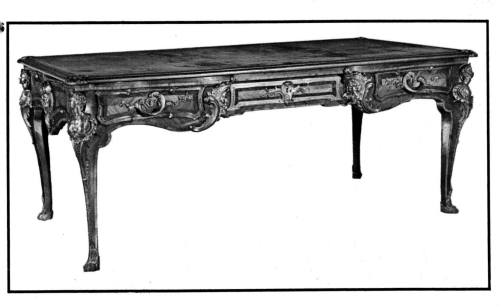

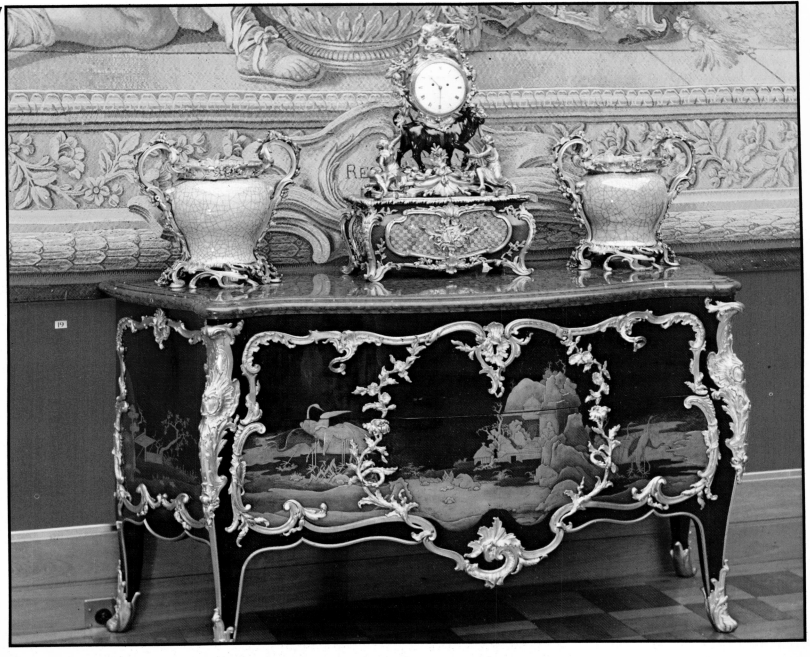

38 *Corner cupboard* by Johann August Nahl (1710–81). **38**
*c.*1745. (Schloss Charlottenburg, Berlin.) In 1741 Nahl, who
had been in Italy and Paris, was made Directeur des Ornements
at the Court of Frederick the Great of Prussia. For the royal
residences at Potsdam and Charlottenburg he designed
furniture and stucco decorations until, in 1746, he and the
architect, Von Knobelsdorf, found the King an intolerable
taskmaster and left Berlin. Nahl later worked at Kassel.

39 *Writing-table* by Abraham (1711–93) and David
(1743–1807) Roentgen made at Neuwied in the Rhineland.
*c.*1765. (Rijksmuseum, Amsterdam.) Abraham Roentgen
returned to Neuwied after a visit to London in the 1730s and
set up his workshops in 1750 at which he was assisted by his
son David from 1761. It soon gained an international reputa-
tion for the quality of the furniture and the ingenuity of its
mechanical devices. The elaborate pictorial marquetry of this
piece is in the tradition of German renaissance furniture, but
the restless contours and the mounts betray its date. David
Roentgen travelled widely, visiting Paris in 1779 where he
received several commissions and was made a *maître ébéniste*
by the Paris Guild.

40 *Commode* designed by François Cuvilliés (1698–1767)
and carved by Johann Adam Pichler for the Kurfurstenzimmer
in the Residenz, Munich. 1761. (Residenzmuseum, Munich.)
Instead of the cast ormolu mounts used in France, the
Bavarian cabinet-makers carved and gilded their decoration
in wood. The extent of Cuvilliés assimilation of French
Rococo may be judged from this piece.

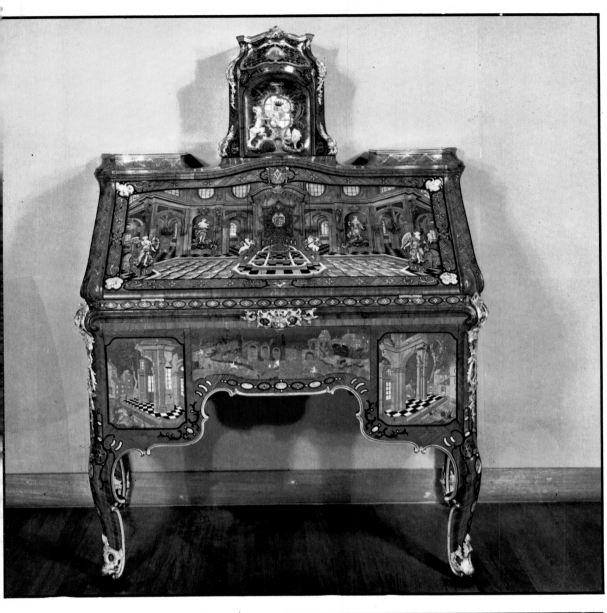

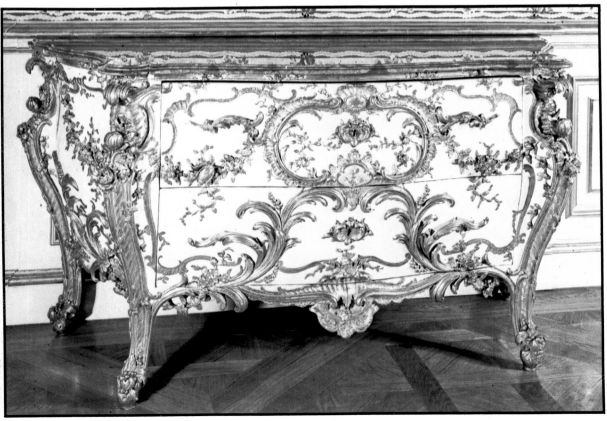

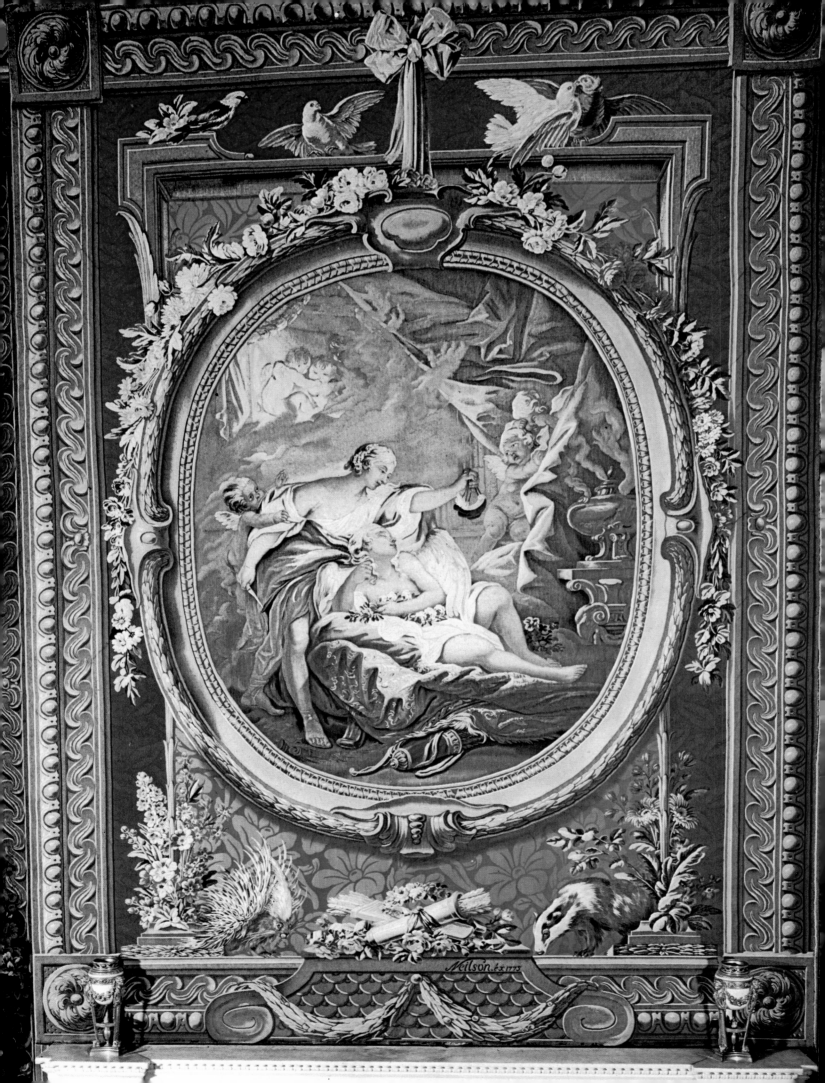

Neilson ex 1775

41 *Cupid and Psyche* from 'The Loves of the Gods', after François Boucher. (Osterley Park House, Middlesex.) Woven at the Gobelin's factory for the Tapestry Room at Osterley Park House and signed and dated by Jacques Neilson, 1775, the background is of the colour called *rose du Barry* named after Madame du Barry, the mistress of Louis XV. The designs of these marvellously light rococo confections were chosen to harmonize with the existing interior decoration of Osterley Park House and were woven to fit the wall panels where they still hang today.

42 *Venus and Vulcan* from 'The Loves of the Gods' after François Boucher. (Osterley Park House, Middlesex.) In the same series as 'Cupid and Psyche' and also signed and dated 1775 by Jacques Neilson, these tapestries signify the aesthetic change in this period, marked by a preference for decorative rather than monumental art. These delightful tapestries provided the perfect background to the new and smaller scale apartments.

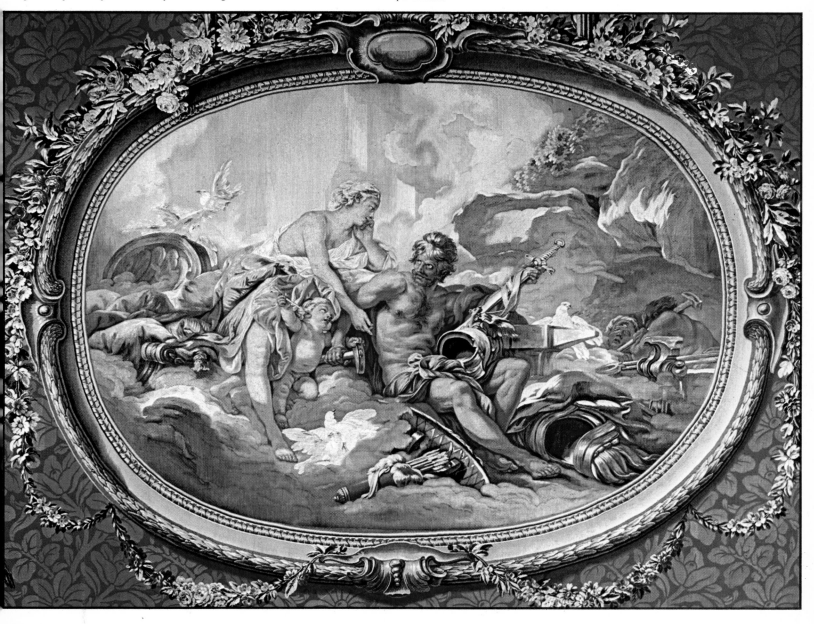

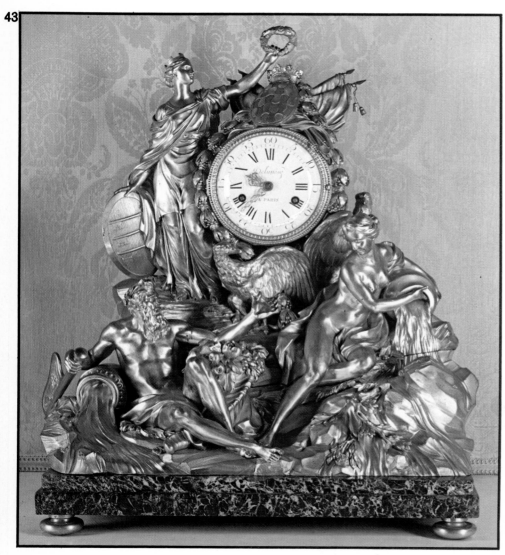

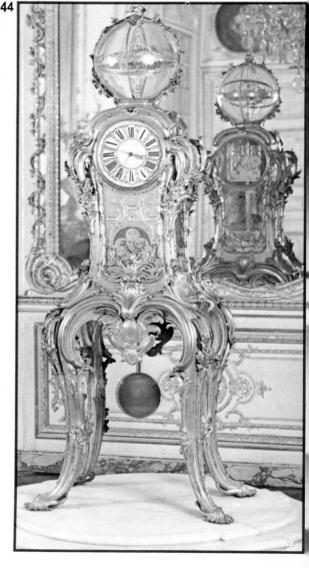

43 *The Avignon Clock*, the case by Pierre Gouthière, 1771 and the movement by N. P. Delunésy (active 1764–83). (Wallace Collection, London.) This magnificent chased and gilt-bronze clock on a marble plinth is surmounted by figures symbolic of the towns of Avignon and of the two rivers, the Rhone and the Durance. It was presented to the Governors of Avignon, J. L. R. de Rochechouart, by the City Council in 1771, and bears his arms. The original bill still exists for the clock, which was priced at 11,414.15 livres, transportation included, of which 9,200 livres went to Gouthière for making the case. Pierre Gouthière was by far the most celebrated craftsman of this period and evolved many new techniques, among which the *dorure au mat* is one of the distinguishing features of Louis XVI ormolu.

44 *The Passemant clock*, the case by Jacques Caffiéri (1687–1755) in collaboration with his son Philippe (1714–74). Mid-eighteenth century. (Versailles.) This famous clock, the case of chased and gilt bronze illustrates the quite astounding virtuosity of two famous craftsmen of the period, Jacques Caffiéri and his son Philippe, son and grandson of a metalworker brought from Italy by Cardinal Mazarin. The quality of their work is proverbial and in both form and execution is possibly the finest monument to the Rococo. It is interesting to note that the French style of the eighteenth century, while uniquely French, was evolved and executed mainly by foreigners.

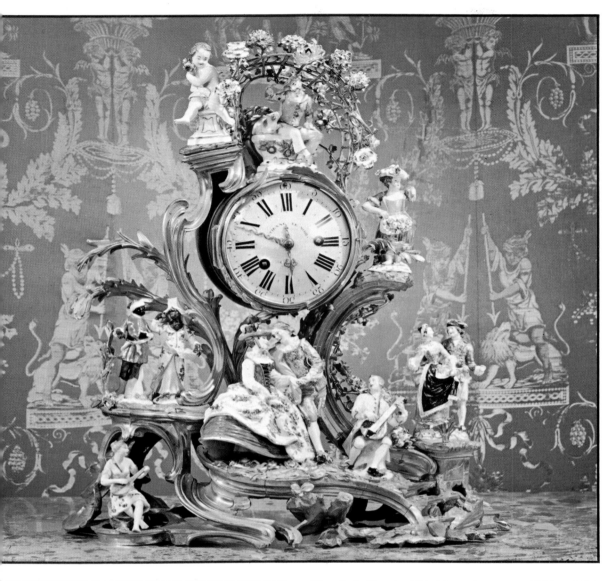

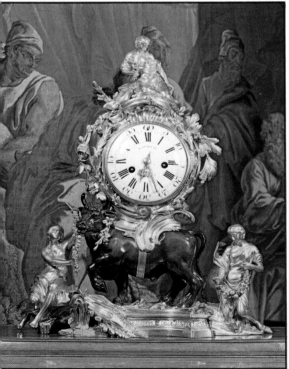

45 *Clock*. French. Mid-eighteenth century. (Schloss Wilthelmstal.) The gilt-bronze mounts of the elegant clock in the full rococo style, are decorated with beautifully modelled Meissen figures, and flowers. The movement is by Etienne le Noir.

46 *Clock*, the case by Jean-Joseph de St. Germain. *c.*1750. (Pelham Galleries, London.) This superb clock illustrates the splendid combination of ormolu with patinated bronze, as well as the inevitable French choice of a classical subject – in this case Europa and the Bull – even on a piece in the full rococo style.

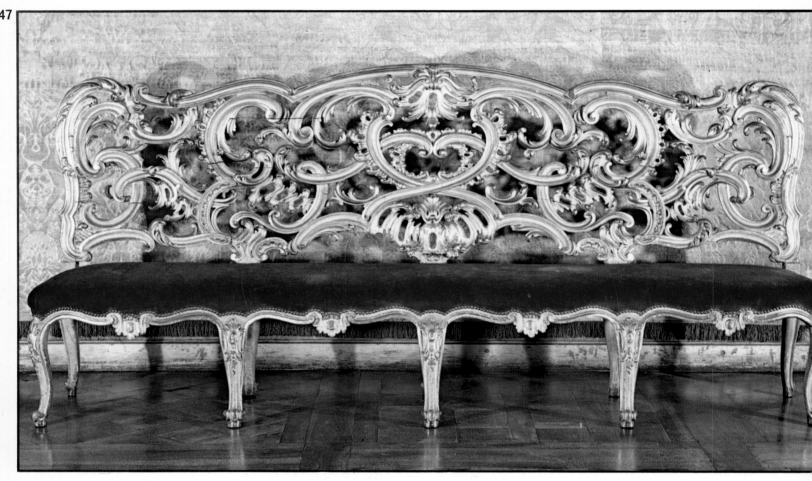

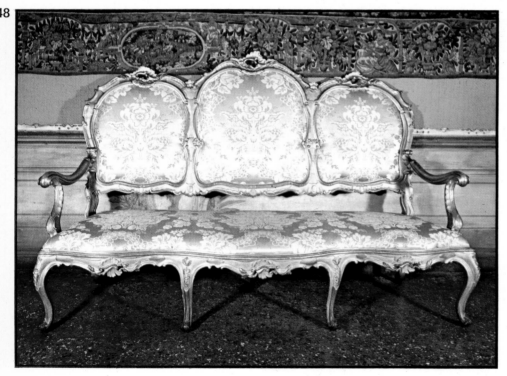

47 *Italian carved and gilt-wood settee*, one of a set of ten, *c.*1725. (Civico Museo di Arte Antica, Turin.) It is almost impossible to believe that this piece with its superb structure and perfectly balanced outline, was not designed by an architect. The strength and the asymmetry of the vigorous C and S scrolls and swirling leaf forms proclaim a confident entry into the rococo style while retaining the severe outlines and grandeur of the baroque. The piece has been re-upholstered in a dark velvet which provides an admirable contrast to the gilding. The settees were designed for the Throne Room of the Madama Reale.

48 *Venetian sofa*, made of carved and gilt-wood, covered with silk. Eighteenth century. (Ca' Rezzonico, Venice.) The *rocaille* ornament on this sofa and its sinuous line reveal the designer's debt to French furniture styles. The gilding of the wood, however, suggests that the exotic woods used to great effect by the *ébénistes* were not available to Venetian craftsmen.

49 *Venetian commode.* Eighteenth century. (Ca' Rezzonico, Venice.) This piece is decorated with yellow lacquer and painted with flowers, a popular form of furniture decoration in Venetian rococo styles.

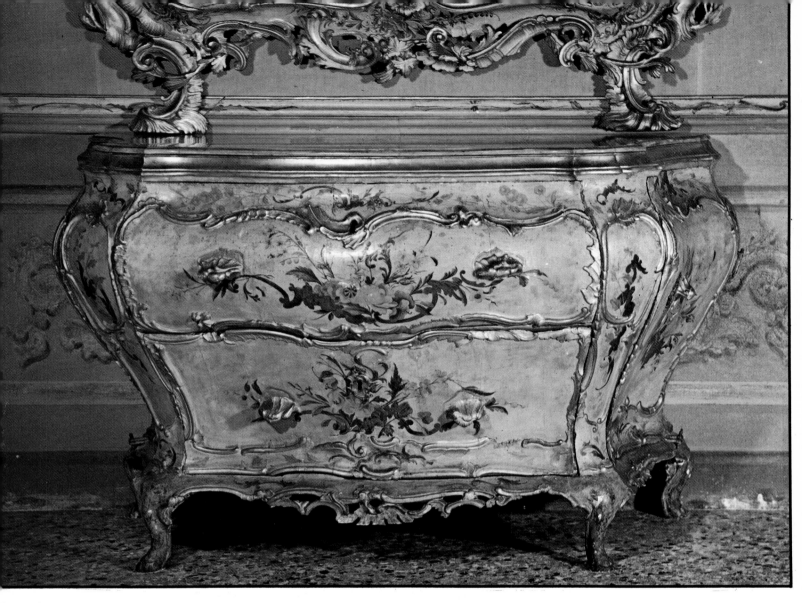

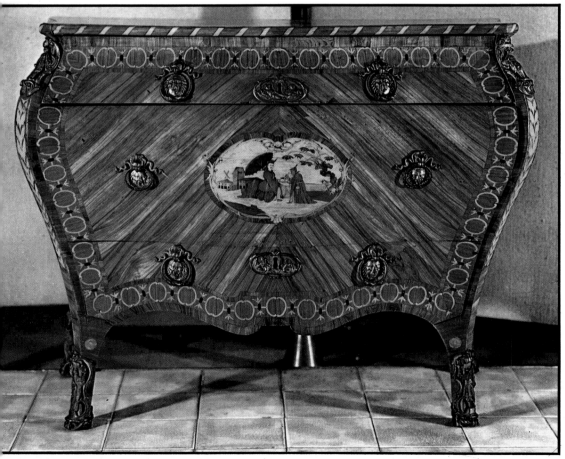

50 *Commode veneered and inlaid with scenes of Chinese life.* (Castello Sforzesco, Milan.) Although this commode is unsigned, it is still characteristic of the Rococo and is thought to be one of the first masterpieces of the artist, Giuseppe Maggiolini. The medallions inlaid in the front and sides of the piece are the work of the ornamentalist Giuseppe Levati, who worked for some time with Maggiolini. These medallions and the bronze handles and escutcheon plates are of Oriental inspiration – a strong rococo feature.

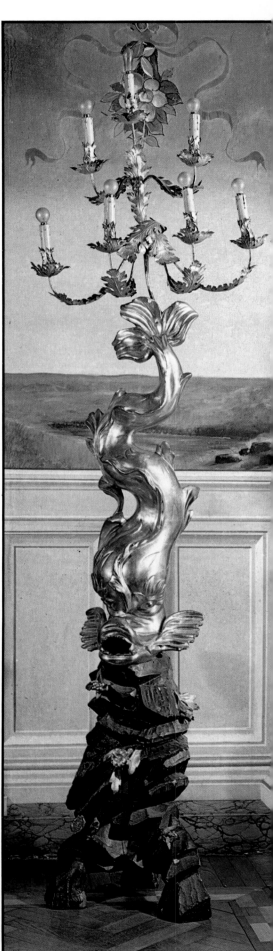

51 *Veneered chest.* (Civico Museo di Arte Antica, Turin.) This richly elegant chest is veneered with rose- and violet-wood and incorporates in the top a medallion depicting, in tortoise-shell, *The Rape of the Sabine Women*. On the front of the drawers the cabinet-maker has created a delicate herring-bone pattern framed by a double stringing of a lighter wood. The elaborate, gilt-bronze handles echo the theme of the side mounts and the huge, upward-curving scroll feet.

52 *Girandole.* (Museo Luxovo, Nervi.) This gilt-metal, seven-branched candelabra is supported by a carved and gilt-wood pedestal in the form of a dolphin on rocks.

53 *Cabinet in the Queen's Closet.* (Palazzo Reale, Turin.) Executed by Pietro Piffetti (*c.*1700–77) during the first years of his residence at Turin, this piece reveals the extraordinary quality of his artistry. This cabinet rests on a console with two scroll feet, itself supported by a table with elegantly curved, slim legs. The framework of this piece is decorated with prickly-pear wood from India and a floral pattern of mother of pearl and ivory, enriched with figures of sirens and cherubs in gilt bronze, which symbolize the seasons. This work is attributed to Francesco Ladatte. Other figures, also in gilt bronze, are the work of Paolo Vernasia. The top of one of the two tables is decorated with the coat of arms of the House of Savoy in which one can see a woman enthroned with a dove in hand. The other table reveals the figure of a goddess standing at an altar. At the sides two putti with shields reveal the initials of the king and queen and the coat of arms of the House of Savoy with the words, '*Fortitudo eius thodum Tenuit*'.

54 *Medal-cabinet* by Pietro Piffetti. (Palazzina di Caccia di Stupinigi, Turin.) A small table on the thinnest curved legs supports the body of this cabinet; mirror-fronted doors open to reveal eight drawers. Beneath the doors is a candle-stand of the finest inlay surrounded by festoons and garlands. At the top of the cabinet is an ornamental motif of an inlaid palmette. The entire piece is inlaid with pale woods. The seasons are worked in ivory veneer, enclosed in elaborate frames in the centre underneath the two doors. Sprays of flowers adorn the front of the table legs and the sides of the piece.

51

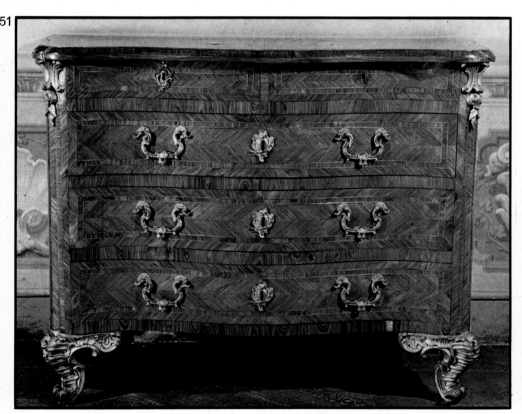

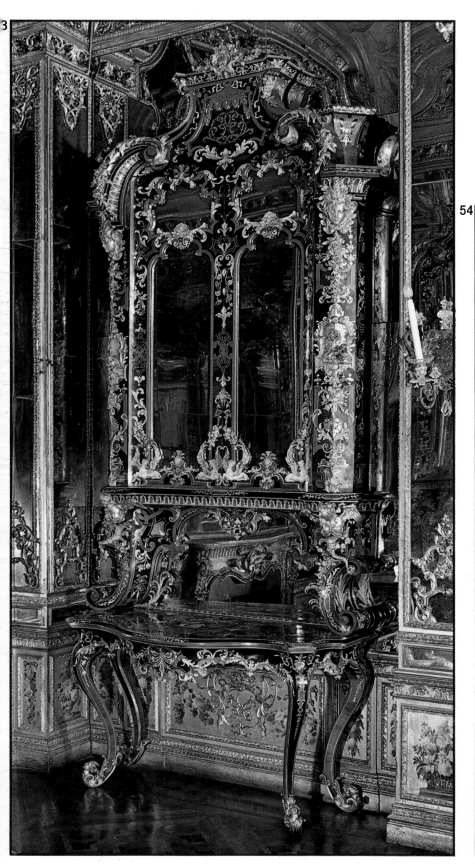

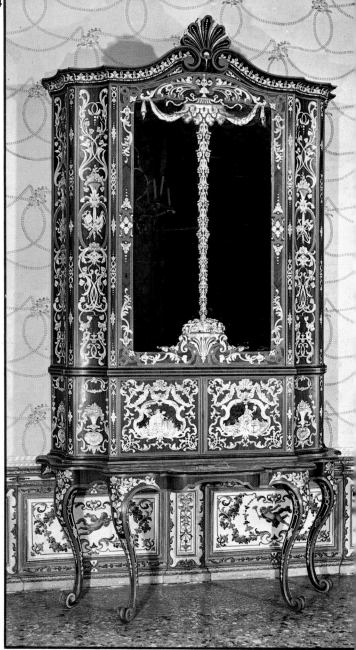

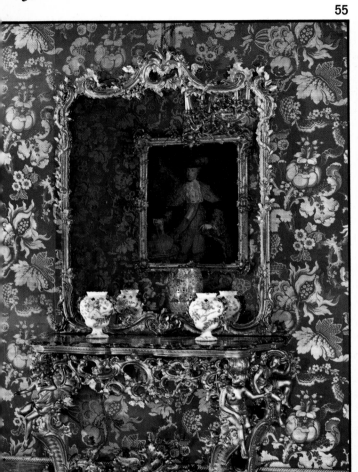

55 *Console-table and mirror*. (Palazzo Reale, Genoa.) This rich console-table, supported by four carved female figures representing the four seasons, is decorated with beautiful and intricate pierced work. The four curling feet are united by cross stretchers which are adorned in the centre by a motif of leaves and wings. The vases on the console are of Marseilles faience of the eighteenth century.

56 *A corner of the Room of Veronese* at the Palazzo Reale, Genoa. Flanked by two lacquered panels with relief in gilt stucco, this carved wooden console is a typical example of Italian rococo furniture, rich in flowing branches and ornamental scrolls with decorated, carved legs. The console is completed by elaborately drossed stretchers surmounted by a rich trophy.

57 *The Music Lesson*, a Chelsea porcelain group. *c.*1765. (Victoria and Albert Museum, London.) This scene is based on a painting by François Boucher called 'L'Agréable leçon' and was made during the Gold Anchor period of 1758–69, which represents the final era of Chelsea as an independent factory. The coloured grounds which Meissen and Sèvres had developed were popular; likewise figures standing on rococo scroll bases bedecked with bocage, a background of flowers and leaves.

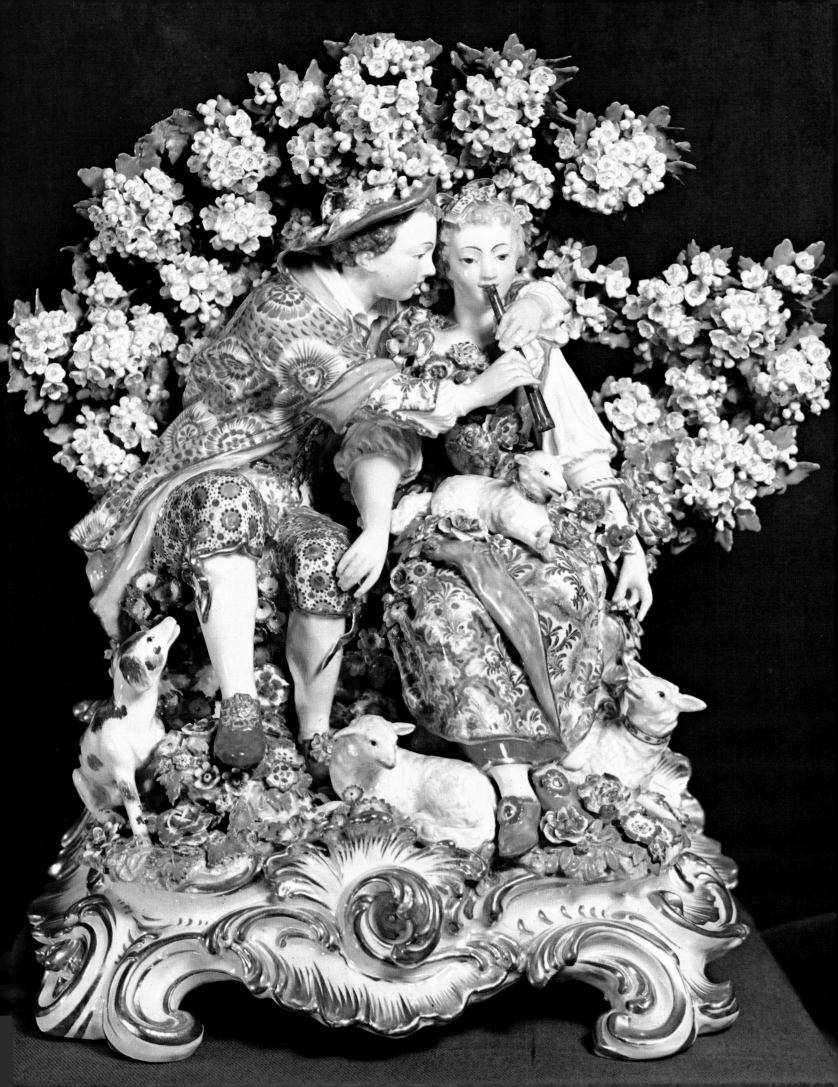

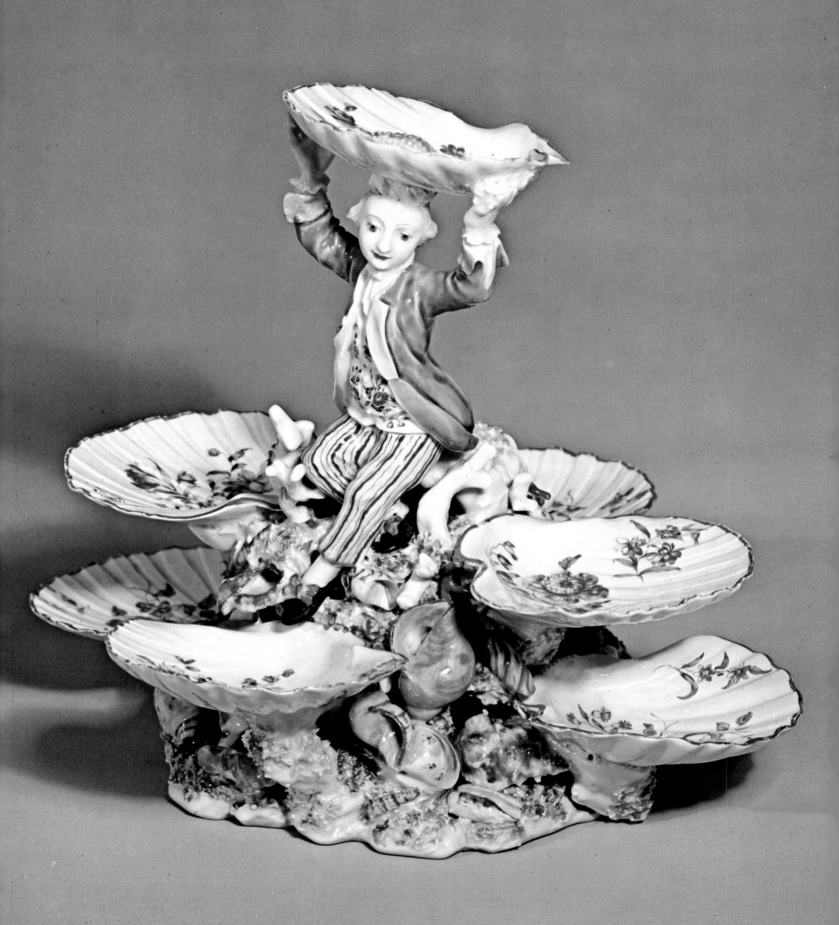

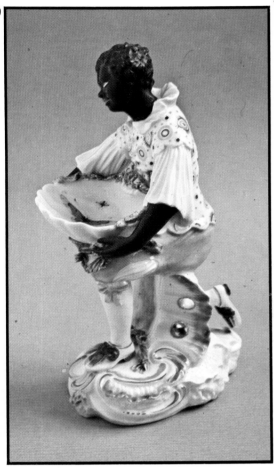

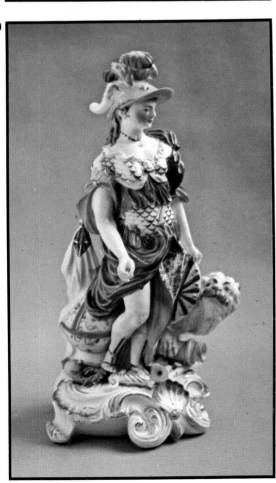

58 *Table centre-piece*, Derby porcelain. *c.*1760–65. (Collection John P. Raison.) Derby wares were generally designed for practical purposes, unlike those of Chelsea, which were often purely ornamental. This typical rococo piece with the shells designed for holding sweetmeats has the 'patch marks' seen so often on Derby wares and caused by the clay pads on which it stood during firing; they provide a useful means of identification.

59 *Figure of a Negro boy*, Derby porcelain. *c.*1765. (Victoria and Albert Museum, London.) The shell held by this graceful serving boy set on a typical rococo scroll base could have been intended for sweetmeats, although the figure could also have been purely ornamental in intent.

60 *Figure of Britannia*. Derby porcelain. *c.*1765. (Victoria and Albert Museum, London.) More figures were made by the Derby factory than by any other English works, but practical wares prior to 1770 are rarer. The earlier figures have a naive charm which was lost with the increasing sophistication of later years.

61 *Pot-pourri*, Bow porcelain. *c.*1760. (Victoria and Albert Museum, London.) This rococo pot-pourri, painted in gay colours typical of the Bow palette and decorated with flowers and masks applied in high relief, is typical of a type of rococo pot-pourri that was also popular at Derby and Worcester.

61

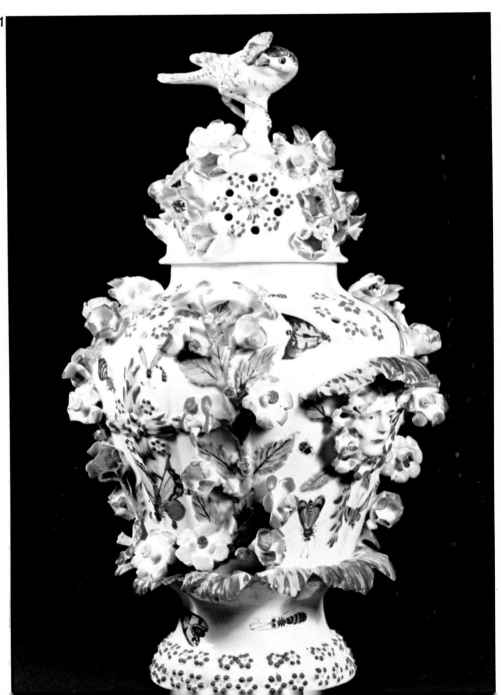

62

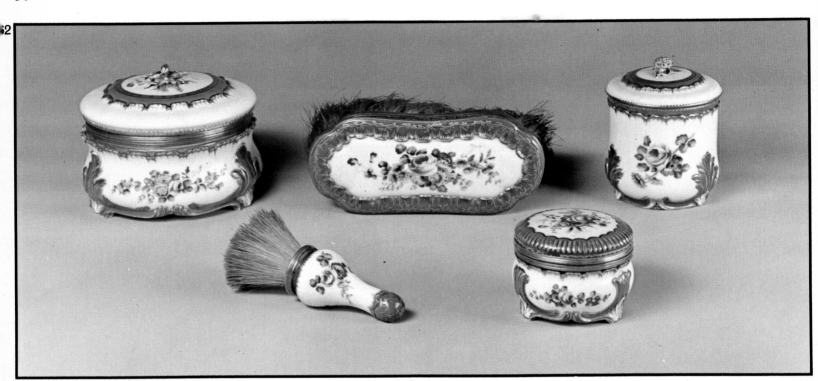

63

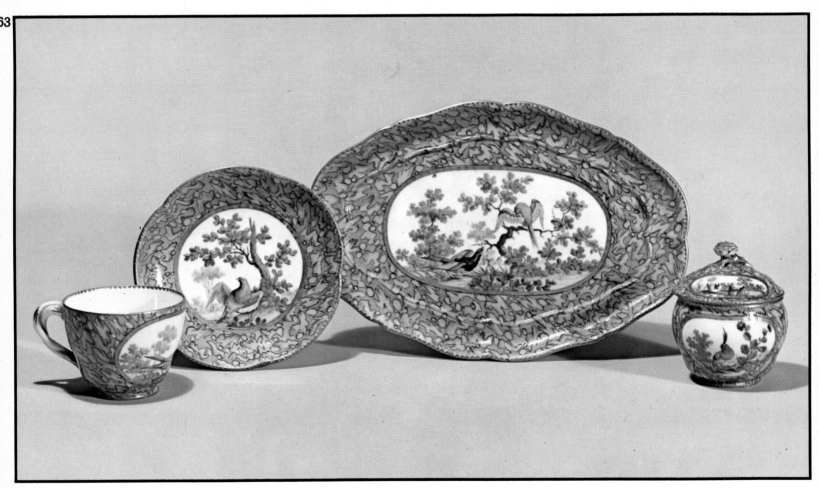

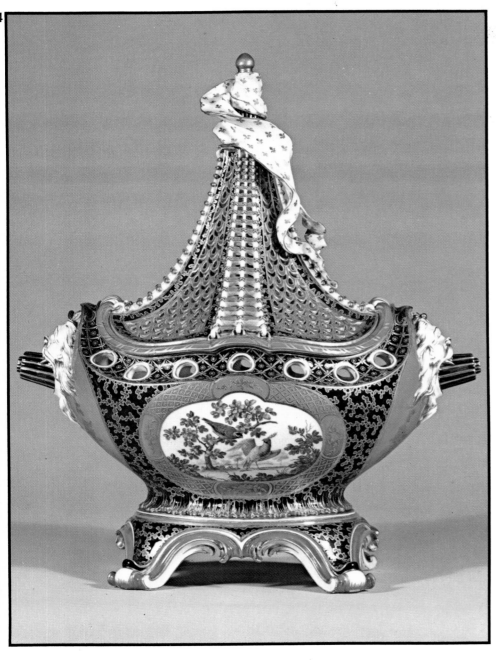

62 *Toilet-service*, Sèvres. Bearing date letters 'K' and 'L' for 1763–64. (Wallace Collection, London.) Toilet sets made of Sèvres porcelain, of which this is a part, are rarely found. It is probable that few were made and that many were broken. This set, painted by Parpette, is said to have been used by Louis XVI.

63 *Breakfast-service*, Sèvres. Bearing date letter 'I' for 1761. (Wallace Collection, London.) This breakfast-service, consisting of a tray, sugar-basin and cup and saucer, is decorated in *rose Pompadour* marbled with gold and blue. It was the enameller Xhrouet who invented the *rose carné* ground-colour in 1757 which was a pure opaque flesh tint difficult to achieve: if the firing temperature were too high, it was converted to a dirty yellow; if too low, it became brownish and mottled. The colour was renamed *rose Pompadour* since it was particularly liked by Madame de Pompadour. Birds, as well as flowers were a favourite theme of Vincennes-Sèvres and François Aloncle (active 1758–81), the painter of this set, was one of the better-known artists who specialized in birds and delightful rococo and baroque landscapes.

64 *Pot-pourri*, Sèvres. *c.*1755–60. (Wallace Collection, London.) Table centres in a design vaguely suggesting a rigged ship, known as *vaisseau à mât* (ship with a mast), are splendid examples of early Sèvres. These are in three parts: a stand with four scrolled legs; a boat-shaped rose-water vessel, the top pierced with circular holes to allow the scent to perfume the room and the lid, which is shaped as a central mask supporting formalized sails and rigging. The scroll base and the elegant white banner of France draped from the mast-top and decorated with gold fleur-de-lis are all characteristic of the best in rococo design.

65 *Allegory of Summer*, a Meissen porcelain figure modelled by F. E. Meyer. *c.*1752. (Victoria and Albert Museum, London.) This figure, painted with enamel colours and gold, comes from a set representing the seasons. The rusticity of subject-matter contrasting with the urbanity of treatment is one of the rococo style's many contradictions which delighted contemporaries. Friedrich Elias Meyer (born 1724) joined the Meissen factory in 1748 and introduced the small heads and elongated bodies which are characteristic of mid-eighteenth-century Meissen figures.

66 *Shepherd with Bagpipes*, a Meissen porcelain figure possibly by J. J. Kändler. (Victoria and Albert Museum, London.) The attribution of this piece to Kändler is suggested by the liveliness and movement of the modelling.

65
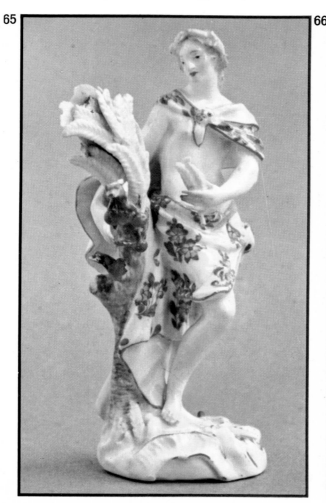

66
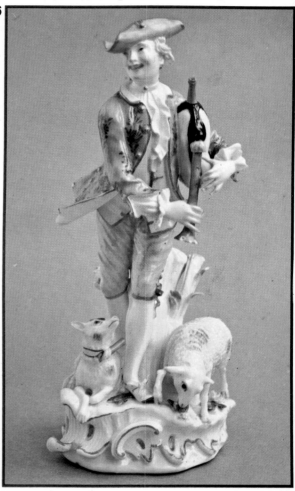

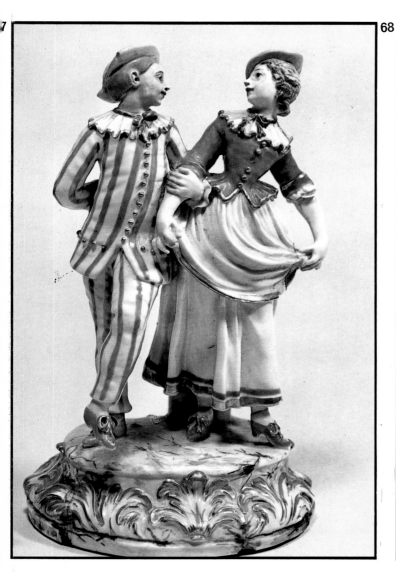
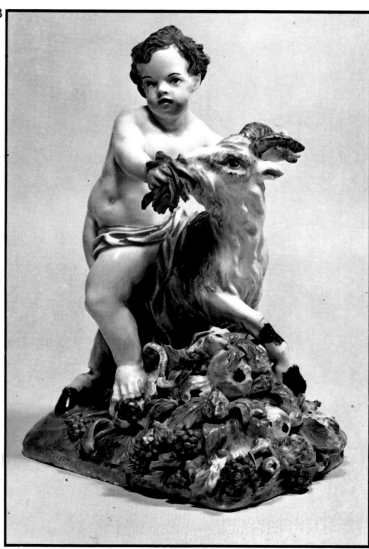

67 & 68 *The Minuet and the Satyr*, porcelain figures from the Capodimonte factory, Naples. (Museo della Villa Floridiana, Naples.) These two pieces were executed between 1743 and 1759. Figures and groups from Capodimonte are renowned for their demonstration of a complete command over the medium and a freshness and originality in their execution.

The Minuet shows a dancing couple, brightly and gaily dressed, performing an elegant step. The pair, with their fine clear-cut features, are standing on a base encircled by curling, gilt-edged leaves.

The Satyr is modelled with a poetic freshness and perfectly balanced composition. He is standing on a small rock which protrudes from a green, flower-strewn hillock, and he is feeding a goat with a handful of leaves.

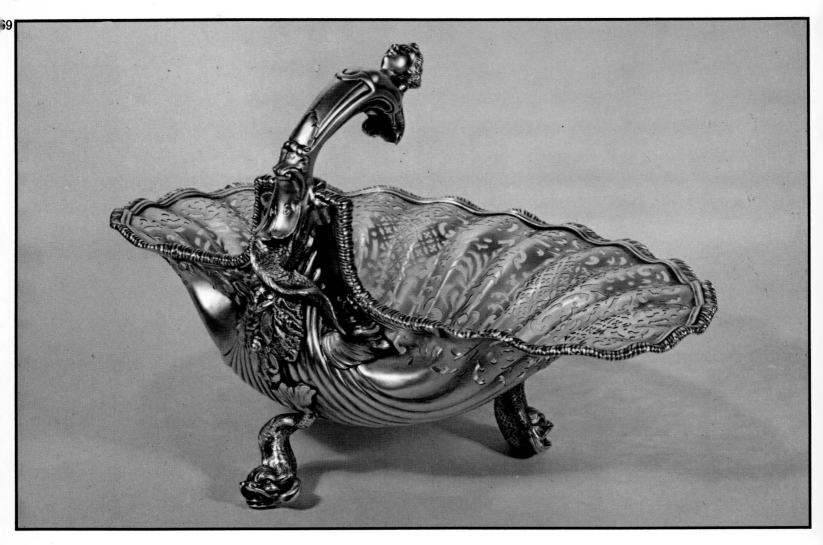

69 *A pierced silver basket* by Paul de Lamerie (1688–1751), London. 1747. (Ashmolean Museum, Oxford.) De Lamerie was born in Liège and was apprenticed to the famous French silversmith, Pierre Platel. Coming to England as a Huguenot refugee he did much to popularize the French Rococo in English silver. He was patronized by the leading nobility, but not by the Crown. This basket is in the form of a shell, one of the commonest decorative motifs of the rococo style. The piercing is a technique commonly found in rococo silver, which gives it an appearance of lightness.

70 *One of a pair of silver sauce-boats* by Charles Kandler, London. 1737. (Ashmolean Museum, Oxford.) The naturalism of the foot, the stork, the crab and the snail indicate the scientific curiosity which was an important aspect of eighteenth-century thought.

71 *A silver, double-branched candlestick* by Frederick Kandler, London. 1752. (Ashmolean Museum, Oxford.) Charles and Frederick Kandler were both of German extraction and the influence of Germany is often clearly discernible in their designs.

72 *A silver tea-caddy* made by Pierre Gillois, London. 1765. (Private collection.) The *chinoiserie* decoration of this piece, unusually, bears some relation to its function.

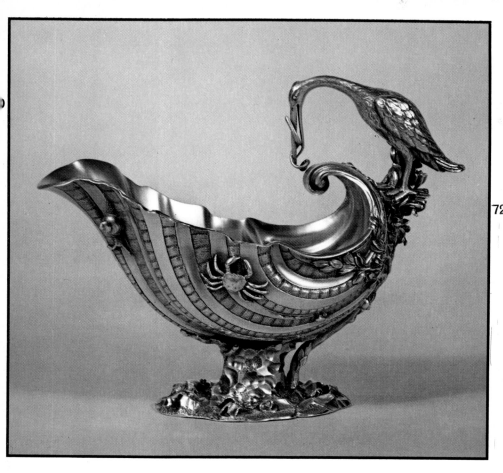

72

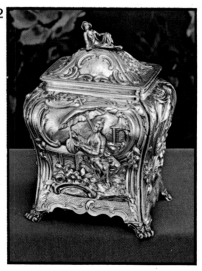

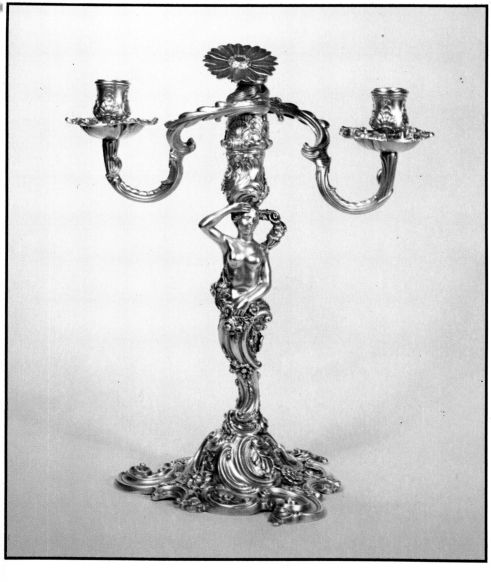

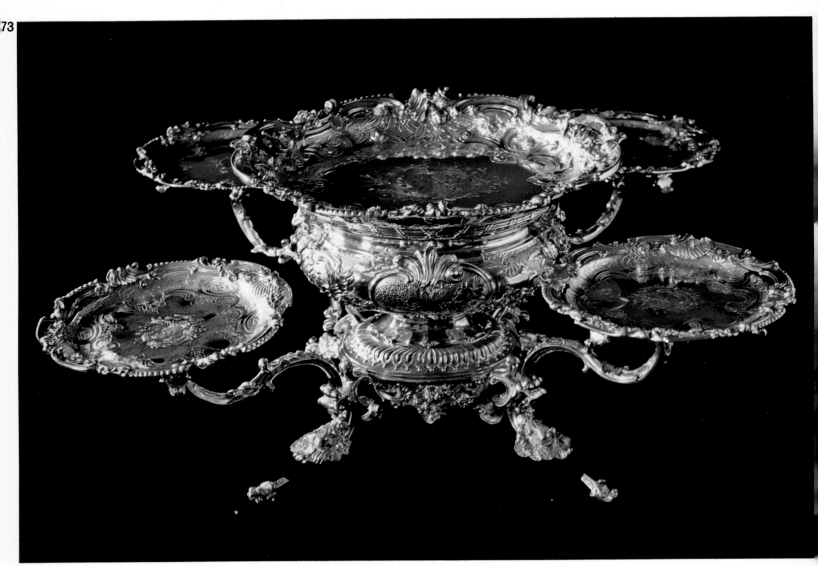

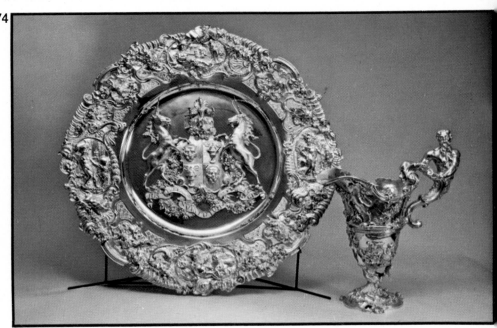

73 *The Newdigate centrepiece* by Paul de Lamerie (1688–1751), London. 1743. (Victoria and Albert Museum, London.) Made as a wedding present for Sir Roger Newdigate, this silver centrepiece with four detachable branches and waiters is a triumph of the silversmith's art. De Lamerie brought to England the flamboyance and virtuosity of the best French silver, although he never lived in France; his parents arrived in London a year after his birth in 1688. In 1703 he was apprenticed to Pierre Platel, like the De Lameries a Huguenot refugee. French Huguenot goldsmiths were renowned for their use of cast decoration which was not a technique widely practised in England at that time, and one ideally suited to the elaboration of the Rococo.

74 *Ewer and basin* by Paul de Lamerie (1688–1751), London. 1741. (Worshipful Company of Goldsmiths, London.) These fine pieces in silver gilt were made to replace the Goldsmiths' Company plate which had been melted down in 1667 and 1711. Their rococo extravagance has a flavour of Cellini's sixteenth-century Mannerism.

75 *Tortoise-shell box in gold posé work with mother-of-pearl inlay*, French *piqué* work, First half of the eighteenth century. (Victoria and Albert Museum, London.) The actual size of this box is only three and a quarter inches in diameter, and the fine work of the French craftsman may be judged from this illustration.

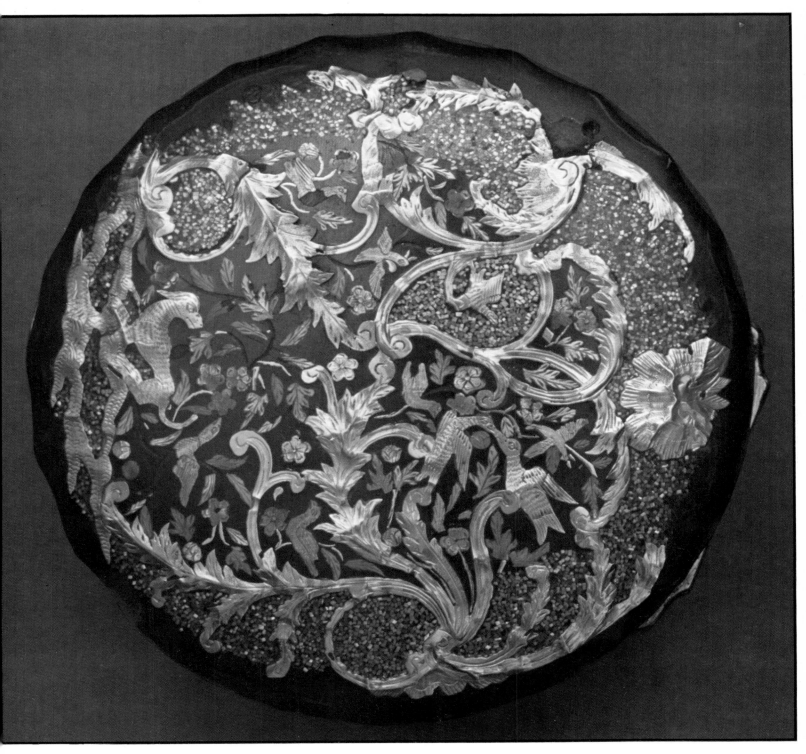

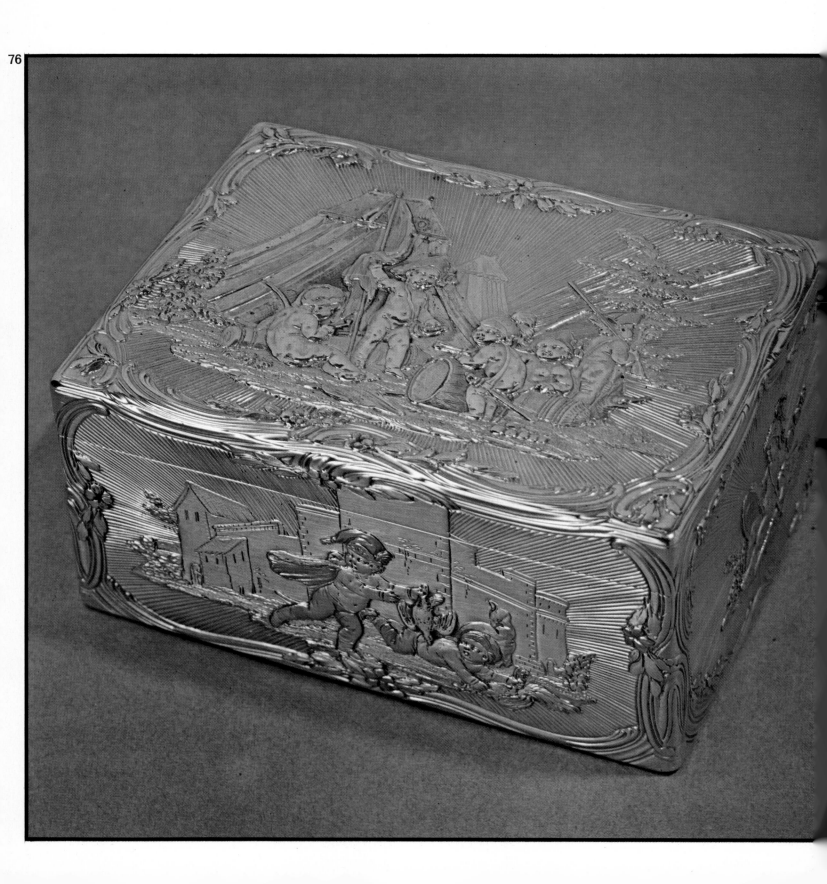

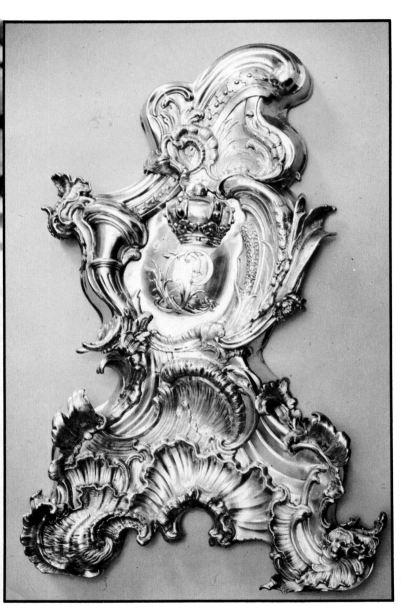

76 *Gold box* by Jean George, Paris. 1757–58. (Wallace Collection, London.) The scenes of small boys playing soldiers on the lid and performing various mischievous acts on the sides of this box were a popular theme of rococo decoration. Pictorial effect is achieved by using four different gold alloys, a technique called '*quatre couleurs*'.

77 *A silver andiron* by Philip Jacob Drentwelt, Augsburg. 1747–49. (Victoria and Albert Museum, London.) From the end of the seventeenth century, silver fire-dogs became increasingly less common in south Germany, where the decorations of the rococo style were known as *Muschelwerk*, meaning 'shellwork'. Very often the German designers over-elaborated original motifs taken from engravings after French artists such as Meissonnier or Pineau.

78

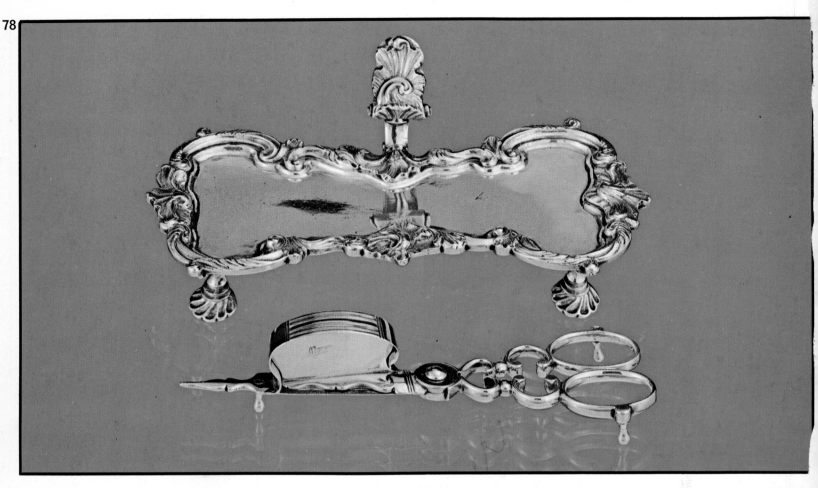

79

78 *Silver snuffers and stand* by Myer Myers (1723–95), New York. *c*.1755–70. (M. B. Garvan Collection, Yale.) In the American colonies the rococo style was not assimilated to any great extent. But the use of scrolls, gadrooning and naturalistic ornament became widespread without the basic forms of an earlier age being lost. The reasons may be looked for in the colonists' lack of sympathy with courtly frivolities rather than in their remoteness from Europe.

79 *Silver dish-ring* by Myer Myers, New York. *c*.1760–75. (M. B. Garvan Collection, Yale.) Myers, who was a member of a Jewish family which had emigrated from Holland, was born in New York in 1723. Nothing is known about his apprenticeship which ended in 1746; by 1755 he was trading in Philadelphia as well as in New York. This is the only recorded American dish-ring; the pieces he made for synagogues are possibly his greatest achievements.

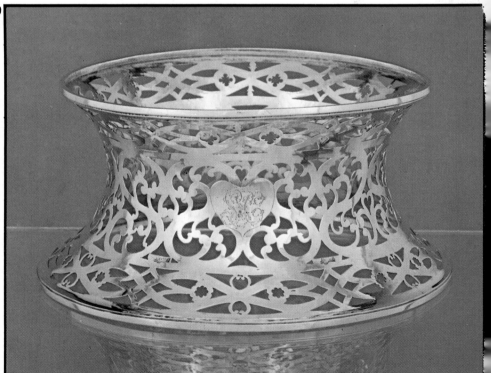